POSTCARD HISTORY SERIES

Victorian Hartford Revisited

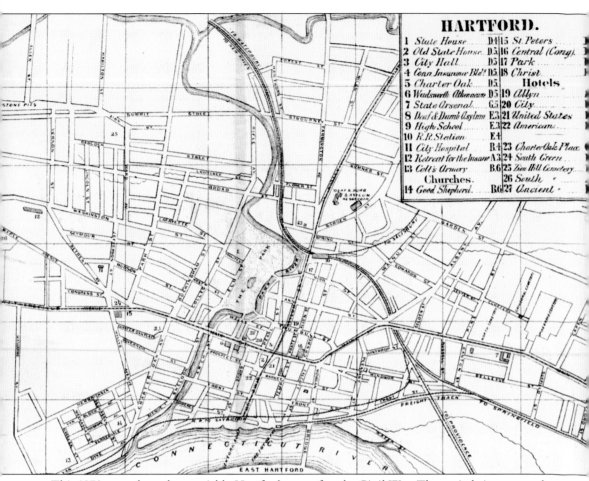

HARTFORD.

1 State House	D4	15 St. Peters	
2 Old State House	D5	16 Central (Cong).	
3 City Hall	D5	17 Park	
4 Conn Insurance Bld?	D5	18 Christ	
5 Charter Oak	D5	**Hotels**	
6 Wadsworth Athenæum	D5	19 Allyn	
7 State Arsenal	C5	20 City	
8 Deaf & Dumb Asylum	E3	21 United States	
9 High School	E3	22 American	
10 R.R.Station	E4		
11 City Hospital	B4	23 Charter Oak Place	
12 Retreat for the Insane	A3	24 South Green	
13 Colt's Armory	B6	25 Zion Hill Cemetery	
Churches.		26 South	
14 Good Shepherd.	B6	27 Ancient	

This 1870s map shows how quickly Hartford grew after the Civil War. The capital city emerged as a leader in manufacturing, banking, insurance, literature, education, social services, and even the park movement. These successes led to great prosperity and the beautification of Hartford.

On the front cover: The hustle and bustle of Victorian Hartford was captured in this image of Main and Pearl Streets. (Author's collection.)

On the back cover: The epitome of Hartford's wealth and success took the form of Armsmear, the 1857 palatial home of Samuel and Elizabeth Colt. This national historic landmark still graces Wethersfield Avenue. (Author's collection.)

POSTCARD HISTORY SERIES

Victorian Hartford Revisited

Tomas J. Nenortas

ARCADIA
PUBLISHING

Published by Arcadia Publishing
Charleston SC, Chicago IL, Portsmouth NH, San Francisco CA

Printed in the United States of America

Library of Congress Catalog Card Number: 2006940198

For all general information contact Arcadia Publishing at:
Telephone 843-853-2070
Fax 843-853-0044
E-mail sales@arcadiapublishing.com
For customer service and orders:
Toll-Free 1-888-313-2665

Visit us on the Internet at www.arcadiapublishing.com

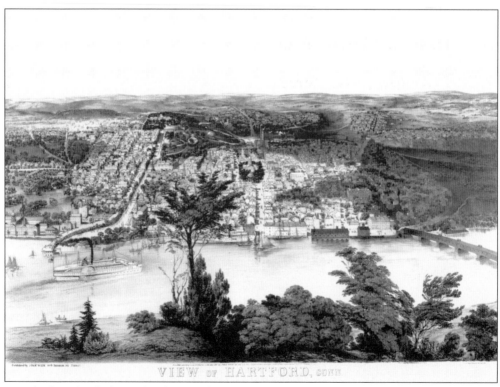

VIEW OF HARTFORD, CONN.

Hartford evolved along the shores of the Connecticut River. Shipping and the railroads connected the city to the rest of the region and beyond. The advent of the automobile severed the centuries-long relationship to the river. Continuing efforts are now being made to reconnect the city and its citizens to the river.

CONTENTS

Introduction 7

1. A Working City 9

2. Public and Private Access 17

3. Downtown Main Street 31

4. Beliefs 39

5. Health and Knowledge 51

6. Reflections 63

7. Visiting the Capital City 71

8. Estates 79

9. Entertainments and Amusements 93

10. Hartford as Home 105

Bibliography 127

This book is dedicated to my parents, Vytenis and Birute Nenortas, for more reasons than they will ever know.

INTRODUCTION

What a difference a year makes. Since the first volume was published, Hartford has made great strides in preserving its historic architecture. The Hartford Preservation Ordinance has been adopted, adding greater protection to the thousands of buildings listed on the National and State Register of Historic Places. More and more people in the city have begun to embrace the concept that buildings should be viewed as assets and not liabilities. Many more are working to preserve and revitalize Hartford's unique architectural heritage and neighborhood character, the mission statement of the Hartford Preservation Alliance of which I am honored to be a part. The capital city's resurgence is tied to the success of its diverse neighborhoods. Pride of place is the main ingredient.

—Tomas J. Nenortas

All images are from the private collection of the author.

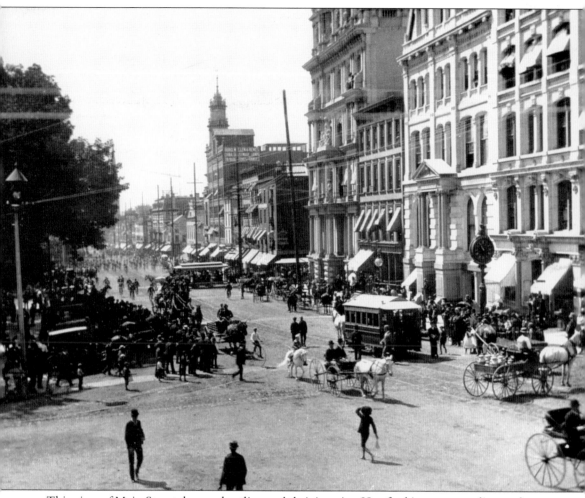

This view of Main Street shows a bustling and thriving city. Hartford is an extraordinary place to be in. Understanding what makes this a great city is vital to exploring what should be done to make it an even greater place to live, work, and visit.

One

A WORKING CITY

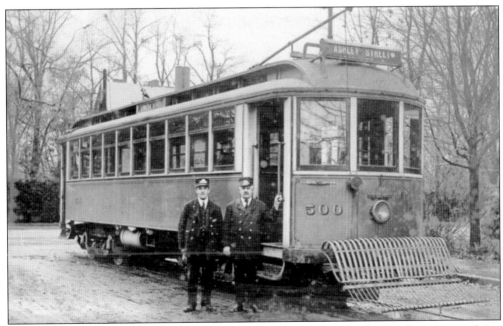

One reason why Hartford expanded so quickly was the extension of trolley lines into outlying neighborhoods. Other cities are reintroducing this economical and less polluting mode of transportation, something tourists enjoy and the city should be considering. Trolley car 500, stopping at Ashley Street, brought residents and visitors to the Asylum Hill neighborhood and the rest of the city.

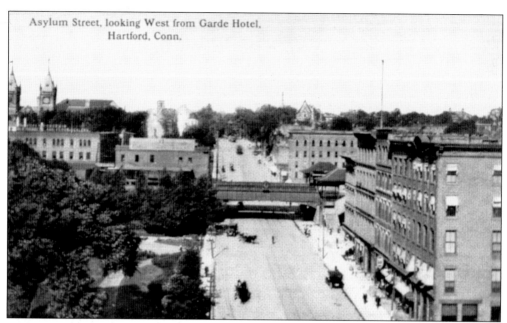

Railroads came early to Hartford, supplanting the need for water transport. This new technology encouraged strong growth in manufacturing and trade. The railroad bridge, shown in the center, traversed Asylum Street and connected Hartford to Connecticut's other lines.

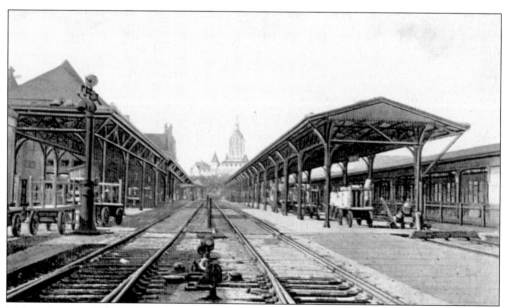

Union station, the main passenger terminal, has been rebuilt twice over the centuries and continues to link passengers to the other cities and towns in the state and the region. Ways of attracting more uses for the restored structure are actively being contemplated.

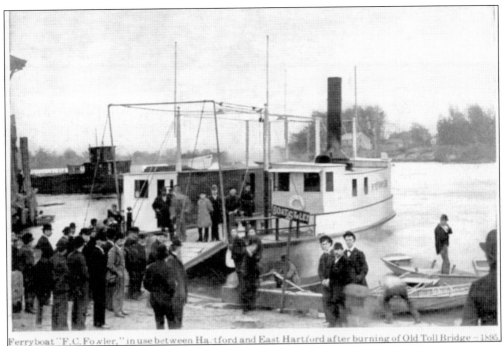

Ferryboat "F. C. Fowler," in use between Hartford and East Hartford after burning of Old Toll Bridge - 1895.

The 1895 destruction by fire of the old wooden bridge that spanned the Connecticut River led to quick and clever capitalistic ideas. People could board a ferryboat or be rowed across by eager entrepreneurs. The new bridge would not be completed until 1908.

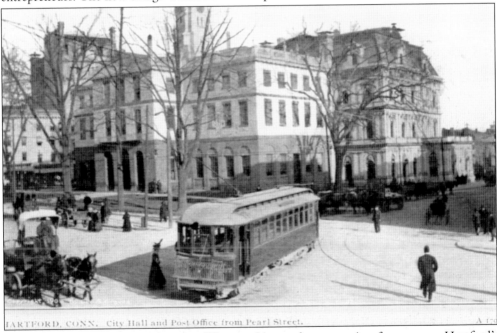

HARTFORD, CONN. City Hall and Post Office from Pearl Street.

Walkers, horses, trolleys, and automobiles would soon be competing for space on Hartford's roads. Within decades, the latter would consume and pollute the city. Reducing this demand is crucial to diminishing the need for parking and eliminating the monstrous garages that have scarred the historic landscape.

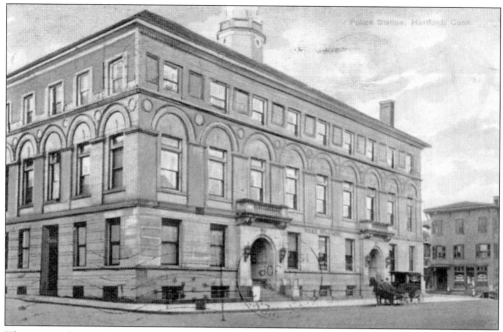

The new police station was built on the site of the old city hall, surrounded by Temple, Market, and Kinsley Streets. This assurance of safety, aided the economic vitality of the Front Street neighborhood. Neighborhood stability leads to economic growth, a factor needed in Hartford's current climb to revitalization.

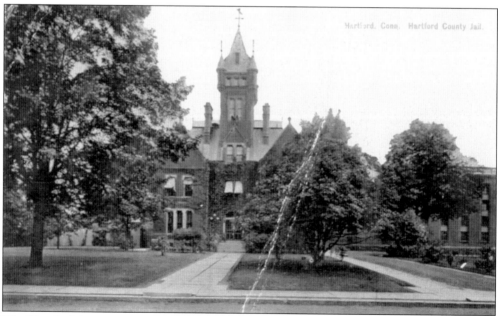

The Hartford County Jail was located in the Clay-Arsenal neighborhood. The 42 Seyms Street building was designed by prolific Hartford architect George Keller in the High Victorian Gothic style. The turreted building was demolished in 1978.

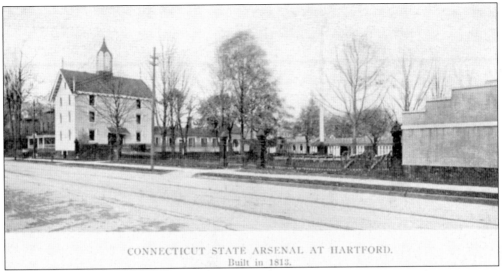

CONNECTICUT STATE ARSENAL AT HARTFORD.
Built in 1813.

Connecticut's State Arsenal was constructed at 264 Windsor Avenue (Main Street) and the corner of Pavilion Street. The 1813 complex ceased operations when the second armory was built downtown at 51 Elm Street.

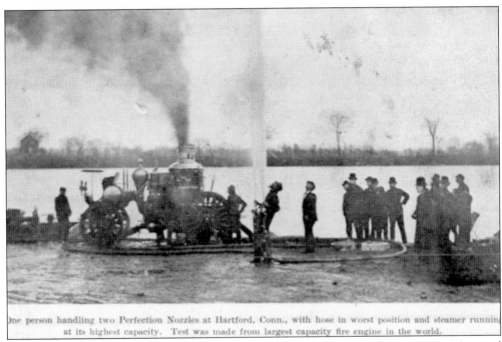

One person handling two Perfection Nozzles at Hartford, Conn., with hose in worst position and steamer running at its highest capacity. Test was made from largest capacity fire engine in the world.

Hartford employed the newest advances in firefighting technology. With numerous stations and alarm boxes located throughout, the city was well prepared to answer any emergency calls. One of the greatest threats to any vacant historic property is an improperly secured building open to arson and vandals, a reason why so many have been lost in the past.

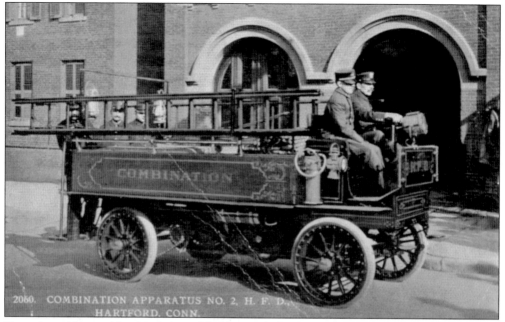

2050. COMBINATION APPARATUS NO. 2, H. F. D.
HARTFORD. CONN.

Two views of a combination hose and ladder truck for the Hartford Fire Department are seen here. It was used by Engine House No. 2. With room for two in front and three in back, the crew was ready to respond to any call for assistance.

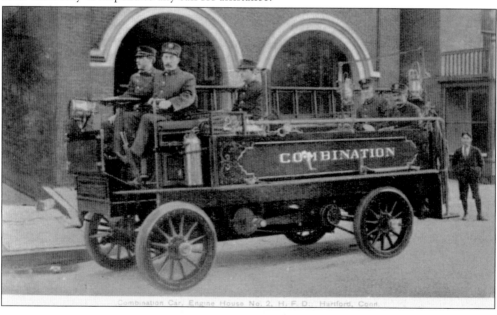

Combination Car, Engine House No. 2, H. F. D., Hartford, Conn

The Hope Engine Company No. 2, seen located here at 5 Pleasant Street, eventually moved to the corner of Windsor Avenue (Main Street) and Belden Street. The company was organized in 1864.

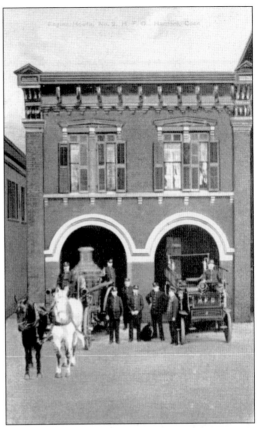

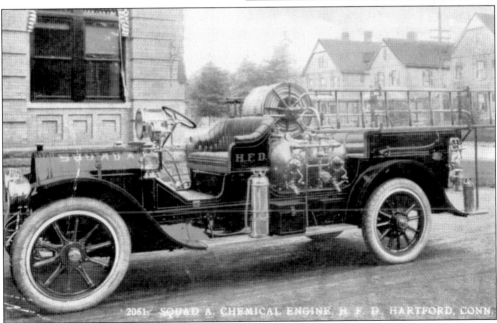

This chemical and hose engine car was built for use by Squad A of the Hartford Fire Department. Fire engines continued to evolve into faster and more efficient vehicles.

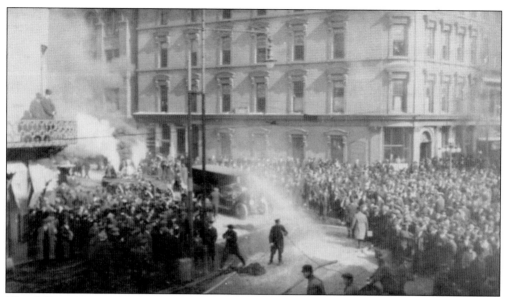

The skills and responsiveness of this fire crew drew great crowds to the intersection of Asylum and Trumbull Streets. The steamer is shown belching smoke and steam.

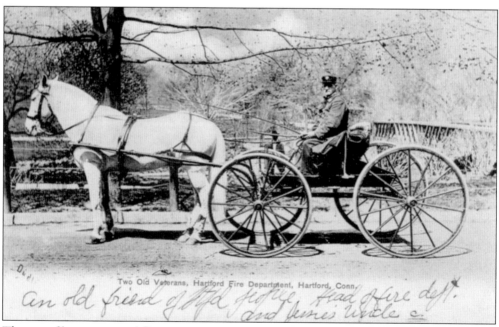

Two Old Veterans, Hartford Fire Department, Hartford, Conn.

An old friend of the people, head fire dept. and James White c.

The age of horse-powered fire apparatus came to an end with the invention of the automobile. Col. Albert A. Pope created a dynasty of bicycle and automobile manufacturing in the city. Many of his Pope engines were used by the department.

Two

PUBLIC AND
PRIVATE ACCESS

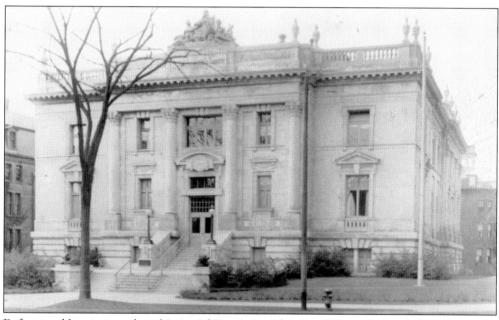

Before world events enveloped Imperial Russia into the Great War and a revolution, the Russia Insurance Company opened at 1565 Broad Street on the corner with Farmington Avenue and across from Hartford Public High School. The stately building was designed by Hartford architect Edward T. Hapgood with a two-story domed atrium and famous "Mother Russia" sculpture. After the building was demolished, the iconic piece adorned the roof of the Russian Lady on Ann Street, temporarily renamed the Lithuanian Lady by its owner John Rimscha, during the collapse of the Soviet Union. With regret by many, the sculpture, which had seen so much history, now sits in the lobby of a New York City hotel.

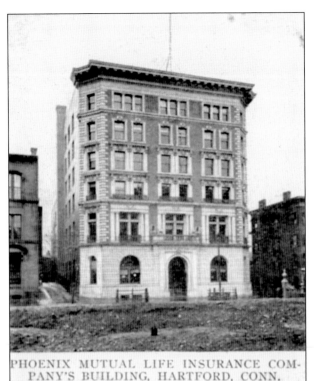

PHOENIX MUTUAL LIFE INSURANCE COMPANY'S BUILDING, HARTFORD, CONN.

This 49 Pearl Street building was home to the Phoenix Mutual Life Insurance Company. The company was founded in 1851 by a group of prominent Hartford religious, civic, and business leaders. Although located in new headquarters, the Phoenix Mutual Life Insurance Company continues today as a major employer in the city. This building did not survive downtown expansion.

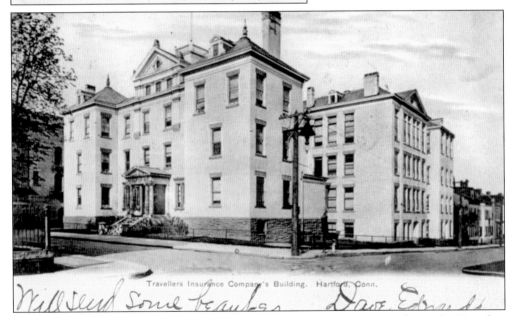

Travellers Insurance Company's Building. Hartford, Conn.

Credited with being the first company in America to insure against accidents, the Travelers Insurance Company was created in 1864. One of their earliest offices was at 56 Prospect Street on the corner of Grove Street. Originally a private home, the building was expanded several times before the company moved to its new location on Main Street. This site was taken over eventually by the Hartford Steam Boiler Inspection and Insurance Company. The structure is no longer standing.

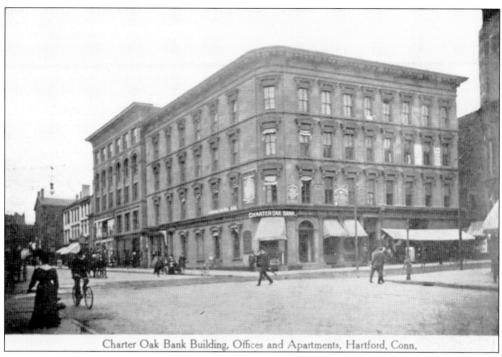

Charter Oak Bank Building, Offices and Apartments, Hartford, Conn.

A viable downtown contains a mix of buildings and uses. The Charter Oak Bank Building still stands on the northeast corner of Trumbull and Asylum Streets. This 1861 brownstone edifice is a reminder of the prosperity of the downtown in the Victorian era.

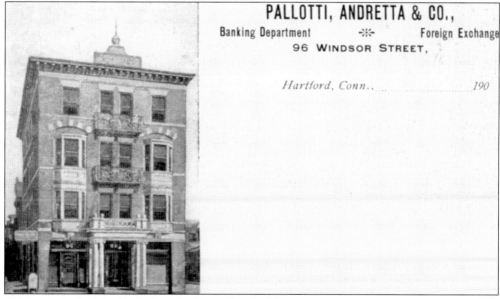

PALLOTTI, ANDRETTA & CO.,

Banking Department ⚹ Foreign Exchange

96 WINDSOR STREET,

Hartford, Conn., *190*

Urban renewal of the 1960s destroyed countless buildings and eliminated many historic streets in the city. Village and Windsor Streets converged to form Village Street Park. Interstate 84 erased this neighborhood, including the site of 96 Windsor Street, which bordered the park.

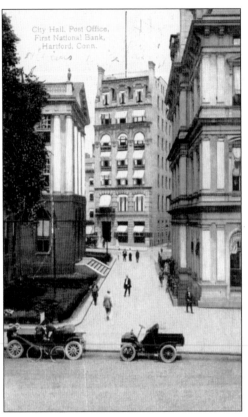

This view shows how close the downtown post office had been built to the Old State House, which was then used as city hall. The building in the center was built in 1899 for the First National Bank and designed by Ernest Flagg. It was saved from demolition and incorporated into the State House Square project of 1985.

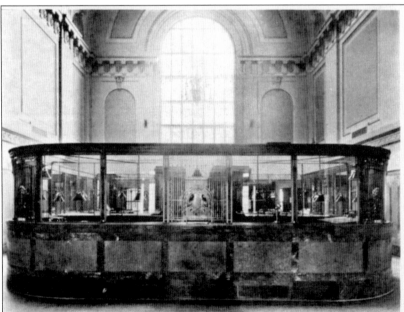

STATE BANK,

Hartford, Conn.

Organized 1849.
Capital, $400,000.
Surplus, $325,000.
Transact a
General
Banking and
Trust Business.
When You Make
Your Will
Name the
State Bank
As Your
Executor
And Trustee.
Your Interests
Will Be
Protected.
Safe Deposit
Boxes
At Moderate
Prices.

The State Bank was incorporated in 1849 and had branches at 39 Pearl Street and 795 Main Street. Although mergers in the recent past have replaced the locally recognized bank names, the capital city still maintains several large financial institutions.

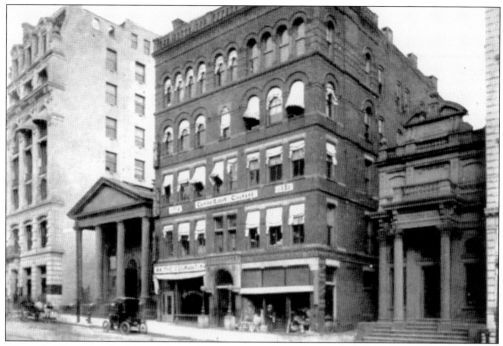

The only Victorian building left on State Street today is the First National Bank building. The others, an eclectic array now lost, were the Greek Temple–styled Hartford National Bank, the Hartford Courant Building, and the ornate National Exchange Bank. State Street was closed to traffic in the 1980s, but there are calls for it to be reopened.

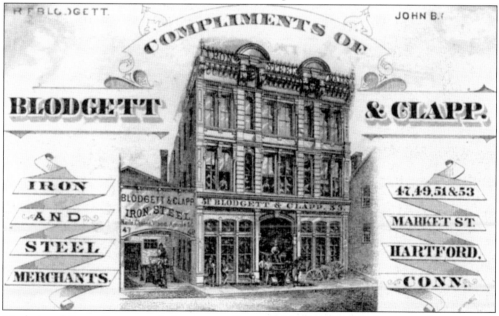

Market and Front Streets and the surrounding neighborhoods were home to the emerging merchant class, as well as the first stop in the lives of many of Hartford's immigrant families. The entire area was eradicated in an ill-advised urban renewal project. Generations who had lived, worked, and shopped here were displaced to other parts of the city.

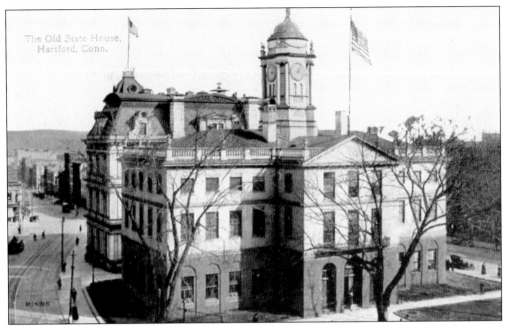

The Old State House, a national historic landmark, was constructed in 1796 to the designs of Charles Bulfinch. Its front facade actually faces the Connecticut River, as Hartford was once a port city. It served its purpose until 1878 when the new state capitol was completed, and it became city hall. When the new Municipal Building was built in 1915, it went through various changes over the years, even being threatened by a plan for a proposed parking garage. It now houses the engaging History Is All Around Us exhibit and is run by the Connecticut Historical Society.

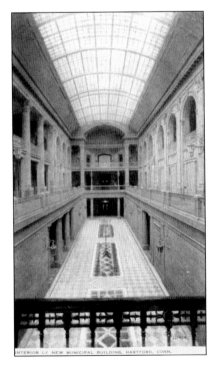

This rare interior view shows the Beaux-Arts atrium of the Municipal Building. The three-story hall is one of the most impressive in the city. From the glass block floor to the vaulted sky-light, the Brooks and Davis with Palmer and Hornbostel designed edifice continues to serve city residents.

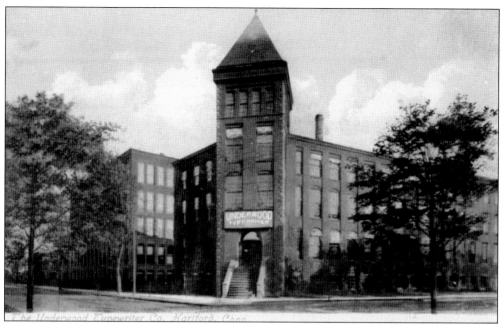

Hartford became a national and international leader in manufacturing technology during America's Industrial Revolution. The products made here were exported to all parts of the world. One of these great producers was the Underwood Typewriter Company. The massive factory lined Capitol Avenue and Woodbine Street. The highway that was constructed in the 1960s went straight through the complex and eliminated Woodbine Street from the map.

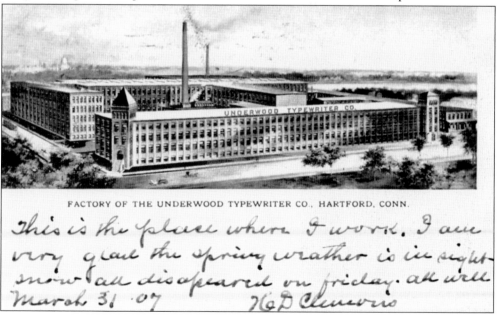

FACTORY OF THE UNDERWOOD TYPEWRITER CO., HARTFORD, CONN.

This is the place where I work. I am very glad the spring weather is in sight. snow all disapeared on friday. all well
March 31 ·07 H & D Clemons

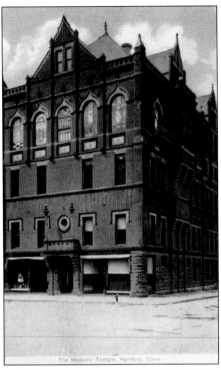

The Masonic Temple, Hartford, Conn.

Brooks M. Lincoln drew up plans for the Masonic hall, which was completed in 1894. The unusually designed Moorish structure arose on the southwest corner of Allyn and Ann Streets. Its intricate stained-glass windows have unfortunately been replaced, but the building still provides a whimsical break in the streetscape.

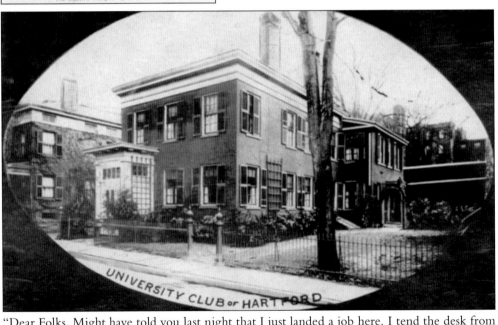

UNIVERSITY CLUB of HARTFORD

"Dear Folks, Might have told you last night that I just landed a job here. I tend the desk from 6 till 10 and receive my supper and forty dollars per month. I work 5 or 6 days a week. Have lots of time to study, etc. Last night I had roast chicken, peas, baked micks and ice cream. Tonight I beat that with Sirloin Steak, French Fries, Peas & Apple Pie a la mode." The Puel family of Brooklyn received this postcard of the University Club at 30 Lewis Street, a great insight into staff life. The former club building and the 1928 addition are currently being renovated using "green building" principles and technology.

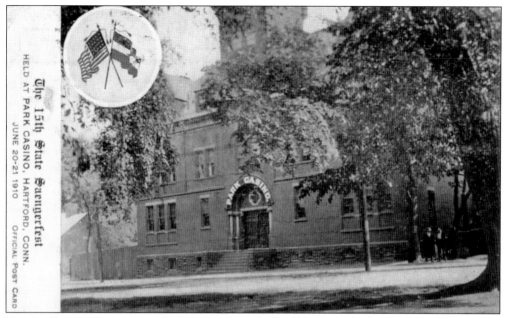

Hartford's second armory was built across from Bushnell Park. Once the third armory was built on Broad Street and Capitol Avenue, the Elm Street building became the Park Casino, hosting various events such as the State Saengerfest of 1910. It was eventually replaced by the Connecticut General Life Insurance Company building in 1926.

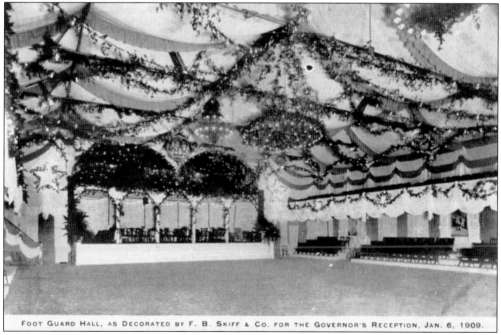

FOOT GUARD HALL, AS DECORATED BY F. B. SKIFF & CO. FOR THE GOVERNOR'S RECEPTION, JAN. 6, 1909.

Foot Guard Hall, by John C. Mead, hosted a governor's reception in 1909, 10 years after it was built in 1889. A letter dated two days after the event thanked the F. B. Skiff and Company of 284 Asylum Street for "the beautiful setting you gave us for our Reception and Ball." The drill hall was advertised as one of the largest, and it continues to hold events to this day.

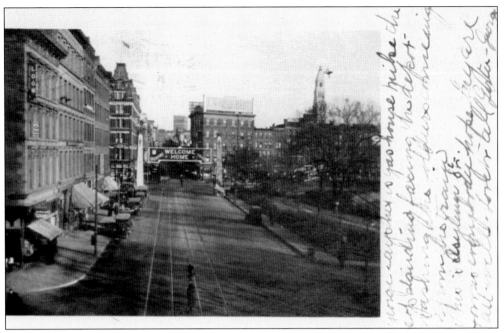

Asylum Street evolved as the premier shopping district in the city. Lined with stores, offices, apartments, and hotels, it was a hub of commercial activity. The pillared sign crossing the street welcomed home soldiers returning from Europe in 1918. These brave souls would have seen this gesture of appreciation as they pulled into Union Station.

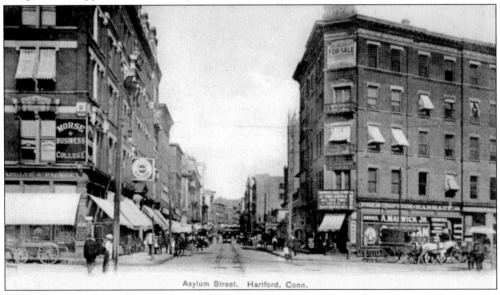

Asylum Street. Hartford, Conn.

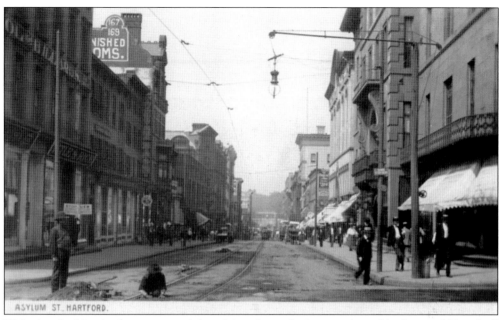

This view looking back west toward the station shows the intersection of Asylum and Trumbull Streets. The Allyn House Hotel, on the corner, and the Hartford Auditorium are to the right, while furnished rooms, Turkish baths, and a pool and billiard hall were advertised across the street. The Harris Parker Company, a block away, enticed children with their wares.

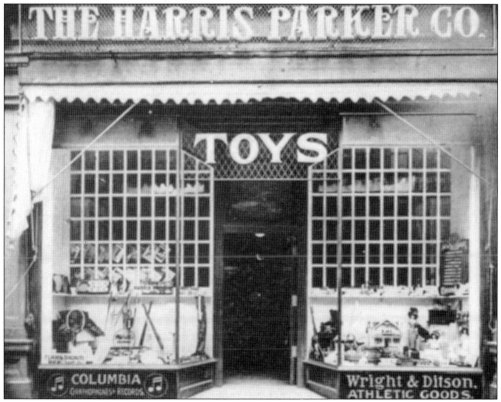

Pratt Street became an exclusive enclave of high-end stores that endured for decades. The charming one block street, between Trumbull and Main Streets, was an ideal place for window shopping. New shopping and dining opportunities have recently reinvigorated this part of downtown Hartford.

SAGE'S,
84-88 Pratt St.,
Hartford.

———

Ladies' Wear
A Specialty.
Suits,
Dresses,
Coats, Furs,
Waists,
Knit
Underwear,
Muslin
Underwear,
Gloves,
Hosiery,
Laces,
Embroideries,
Corsets,
Silks, Etc.

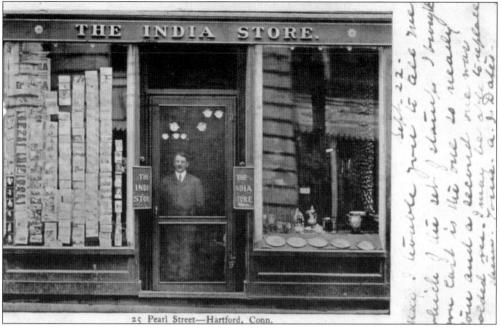

The India Store at 25 Pearl Street and the Farmington Avenue Market on the ground floor of the 57 Farmington Avenue Hotel highlight what made downtown an economically viable commercial district. Mixed uses and residents with mixed incomes are what make downtowns successful. Efforts are continuing to revitalize the downtown core and heart of the city.

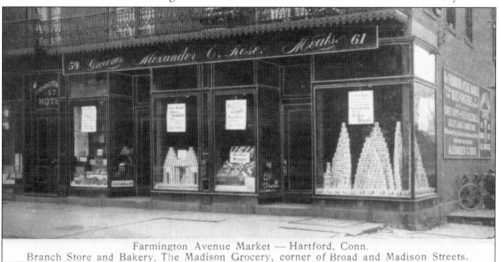

Farmington Avenue Market — Hartford, Conn.
Branch Store and Bakery, The Madison Grocery, corner of Broad and Madison Streets.

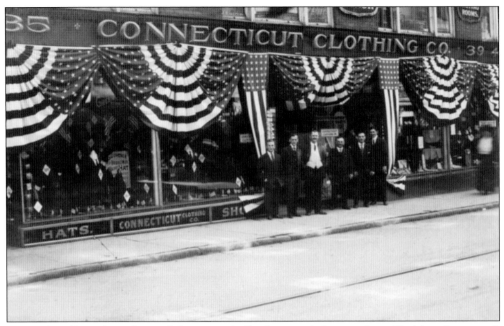

A proud staff stands in front of the patriotically decorated Connecticut Clothing Company's storefront on Asylum Street. Main Street, which runs from the Windsor town line to Wethersfield Avenue, has been a crucial commercial link to the region ever since it was first laid out.

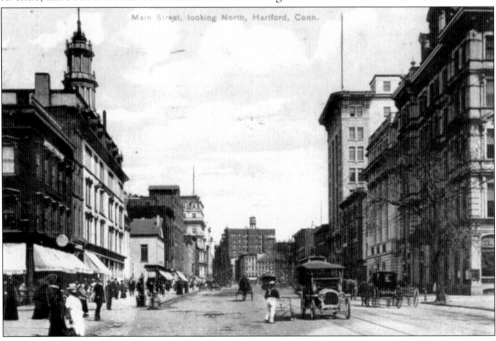

Three

DOWNTOWN
MAIN STREET

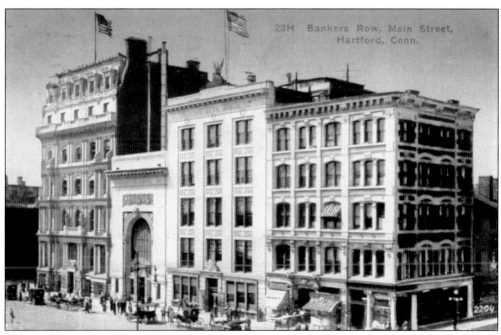

Hartford was not only a leader in the insurance industry but a center for banking institutions. Bankers' Row, on the west side of Main Street between Pearl and Asylum Streets, contained the headquarters for the Hartford National Bank and Trust Company, the State Bank, and the Phoenix National Bank. These three buildings were gone by 1967. The office structure on the right was replaced by the 1929 Corning Building, which still stands on the corner with Asylum Street.

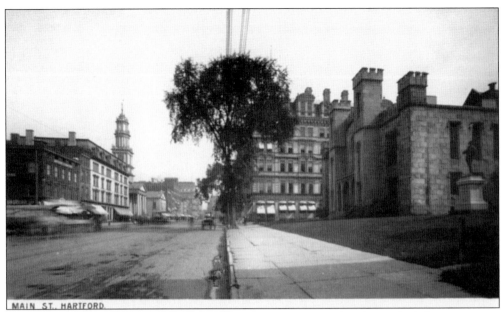

MAIN ST. HARTFORD.

These views look north on Main Street. The spire of Center Church, on the left, towers over its neighbors. The congregation is celebrating its 375th anniversary and continues to maintain a strong presence on Main Street. Besides the church and the Wadsworth Museum on the right, everything else has been razed and replaced by less appealing architecture.

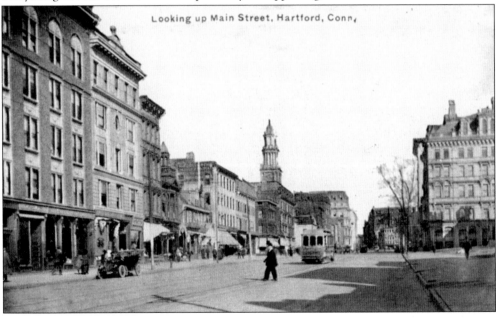

Looking up Main Street, Hartford, Conn,

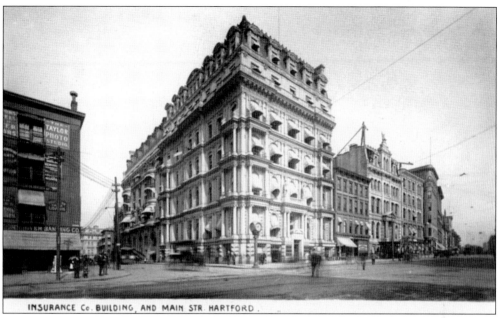

INSURANCE Co. BUILDING, AND MAIN STR. HARTFORD.

Before the Hartford National Bank and Trust Company moved into the massive building in the center, it was home to the Connecticut Mutual Life Insurance Company. Built in 1870, it was remodeled when two more floors were added, and it doubled in size. This block held the most impressive downtown Victorian construction of its day.

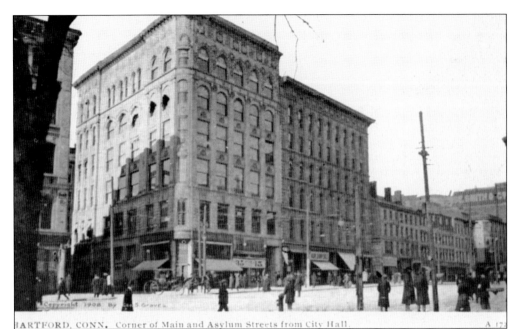

HARTFORD, CONN. Corner of Main and Asylum Streets from City Hall. A 171

The next block north also held a pleasant array of commercial buildings. This entire block has been vacant and used as a parking lot ever since a skyscraper project fell through over a decade ago. The Connecticut Main Street Center, located in Hartford, is a statewide organization committed to bringing back commercial districts and spurring economic development within the context of historic preservation. To prevent further needless demolition, the Connecticut Main Street Center's strategies are being implemented by communities across the state.

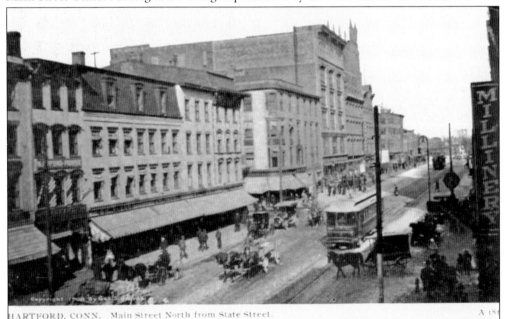

HARTFORD, CONN. Main Street North from State Street. A 181

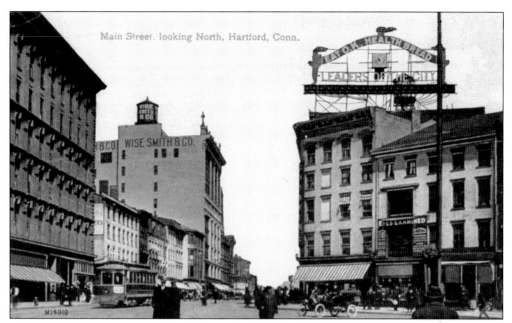

Three major commercial streets came together when Asylum and Pratt Streets spilled onto Main Street, creating an incredible shopping district. Efforts continue to be made to bring back more residential and mixed-use ventures to this part of Main Street.

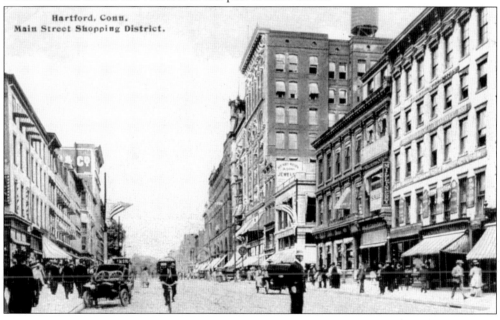

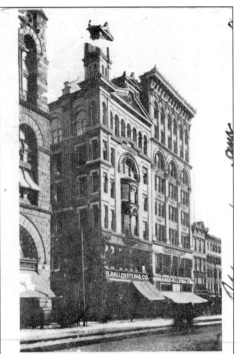

Ballerstein and Sage-Allen Buildings
Offices and Apartments — Hartford, Conn.

The Ballerstein Building, with its unique side clock tower, had already been lost to downtown development before efforts were made to restore the Sage-Allen Building. Unfortunately the sympathetic restoration has been marred by two book-end additions that take away from the 1898 Isaac A. Allen Jr. facade.

One of downtown's landmarks continues to be the Henry Hobson Richardson designed Cheney Block, center, constructed in 1876. Known variously as the Richardson, Cheney, or Brown-Thomson Building, the architectural style of the building has been named Richardsonian Romanesque. Considered to be one of America's greatest 19th-century architects, Richardson employed Stanford White to oversee its construction.

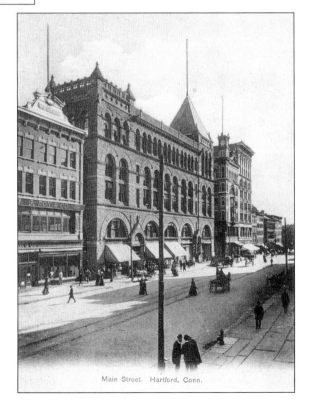

Main Street. Hartford, Conn.

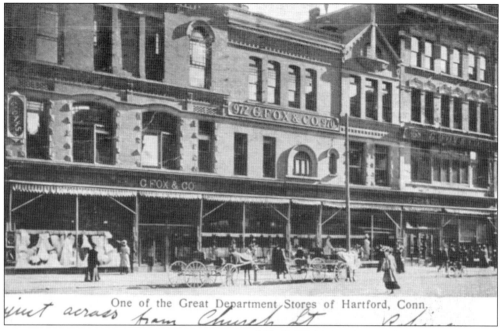

One of the Great Department Stores of Hartford, Conn.

just across from Church St R.

Next door to the Cheney Block was the great mercantile empire created by Gerson Fox in 1847. By 1909, his son Moses expanded the business to several buildings. A great fire calamity claimed the landmark store on January 29, 1917. It was rebuilt in 1918 and brought to even greater success by Gerson's granddaughter Beatrice Fox Auerbach. The store has been reclaimed as a community college, an appropriate adaptive reuse that brings people back onto the surrounding streets.

THE MOST MODERN DEPARTMENT STORE IN NEW ENGLAND.

G. FOX & CO'S NEW BUILDING, HARTFORD, CONN.

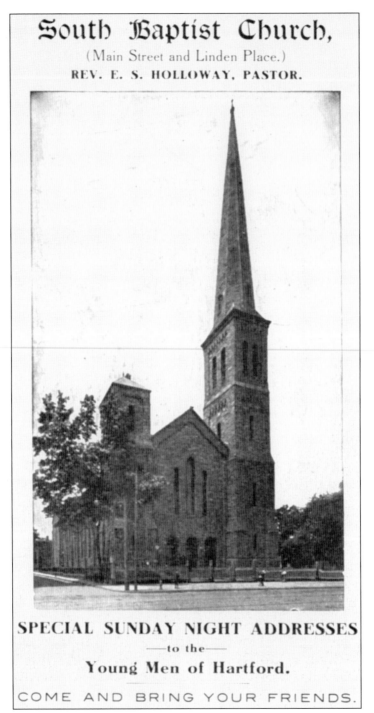

South Baptist Church,

(Main Street and Linden Place.)

REV. E. S. HOLLOWAY, PASTOR.

SPECIAL SUNDAY NIGHT ADDRESSES
——to the——
Young Men of Hartford.

COME AND BRING YOUR FRIENDS.

Main Street was once lined with the tremendous spires of several congregations. The South Baptist Church, on the corner of Linden Place, was no exception. Located at 455 Main Street, it was organized on October 21, 1834, and dedicated on April 23, 1854. It held a chapel, Sunday school, and a 1,200-volume library. It was replaced in 1924 by the Central Baptist Church building, another Isaac A. Allen Jr. commission.

Four

BELIEFS

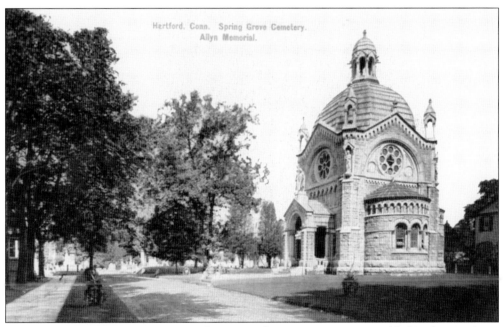

Spring Grove Cemetery was organized in 1845 when 55 acres were assembled in the Northeast neighborhood. It was a private association of Hartford's elite and wealthy families. At one time, the Allyn Memorial Chapel stood majestically at the entrance to the grounds. It was donated by T. M. Allyn and completed January 1, 1883. With disbelief, the stone structure burned down and was forgotten for decades until photographs were recently discovered. The cemetery has been brought back from near ruin by the dedicated efforts of manager Albert F. Lennox and the board of directors.

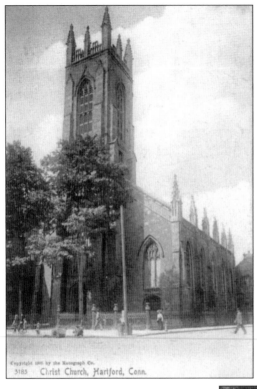

Copyright 1905 by the Rotograph Co.
3185 Christ Church, Hartford, Conn.

The Gothic Revival–styled Christ Church Cathedral is said to be the first example of Gothic Revival church architecture in the country. The cornerstone was laid on May 13, 1828. Organized for the Episcopal faith, the structure has undergone several alterations and additions over the centuries, including a current exterior restoration. The Christ Church Cathedral still proudly commands the corner of Main and Church Streets today.

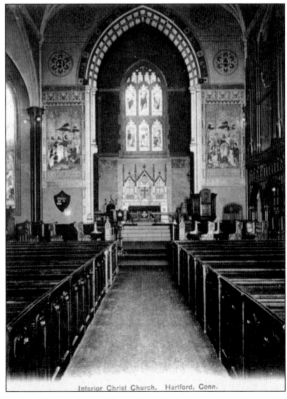

Interior Christ Church, Hartford, Conn.

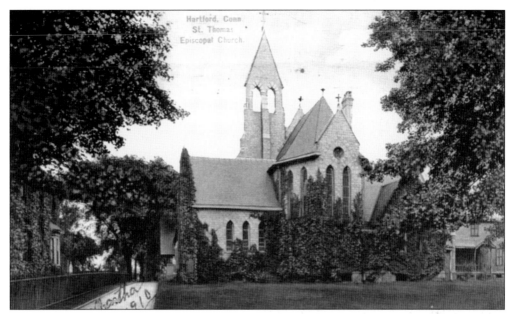

St. Thomas Episcopal Church was organized in July 1870 with a dedication that followed on December 21, 1872. The church was located at 245 Windsor Avenue (Main Street) and included a Sunday school and a wooden church hall attached to the rear. It abutted the grounds of the Old North Cemetery and was across the street from the old state arsenal. A visit to 1921 Main Street today indicates the new steward of the building as the Union Baptist Church and reveals that the tall triangular spire has been removed.

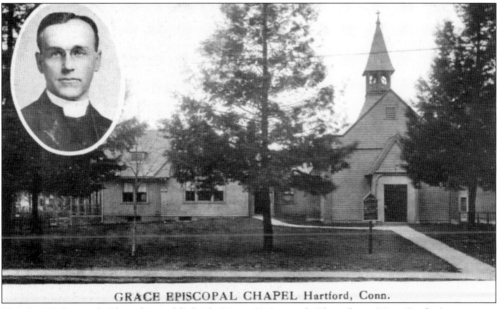

GRACE EPISCOPAL CHAPEL Hartford, Conn.

Trinity Episcopal Church established Grace Episcopal Chapel on New Park Avenue on November 11, 1868. It was built as a mission and Sunday school for the increasing immigrant population in the Parkville neighborhood. Unfortunately the quaint wooden exterior was hidden in 1967 by the addition of a brick bell tower and new facade. The building remains on the corner of New Park Avenue and Grace Street.

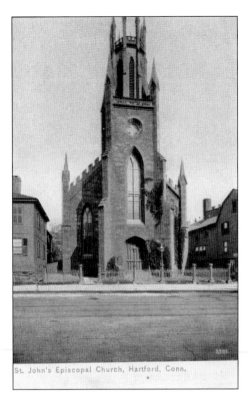

St. John's Episcopal Church, Hartford, Conn.

St. John's Episcopal Church was organized on March 18, 1841, with a cornerstone laying ceremony on July 14, 1841. The original design by Henry Austin included a spire that was removed in 1875 for structural reasons. The last service was held on March 31, Easter Sunday, 1907. The edifice had been bought by J. P. Morgan for his planned gift expansion of the Wadsworth Atheneum, which was two lots down from the church. The parish moved to 679 Farmington Avenue in West Hartford and built a new church where it continues to welcome worshippers.

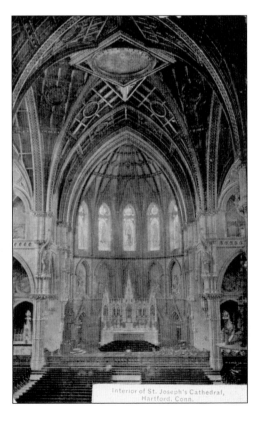

Interior of St. Joseph's Cathedral, Hartford, Conn.

This rare Victorian view inside the Cathedral of St. Joseph shows the ornate altar and vaulted ceilings of the cathedral's interior. A suspicious fire on December 31, 1956, destroyed the 1877 Roman Catholic structure at 150 Farmington Avenue. Salvaged architectural elements lay near the Lithuanian Wayside Cross on the grounds of the new cathedral that replaced this gem in 1962.

"This beautiful church, situated on Clark Street, is built of white buff brick and is Renaissance in architecture. The cornerstone was laid July, 1900, and . . . dedicated . . . June 24, 1906. The interior . . . is of quartered white oak." So read the dedication booklet of this John J. Dwyer–designed Roman Catholic church.

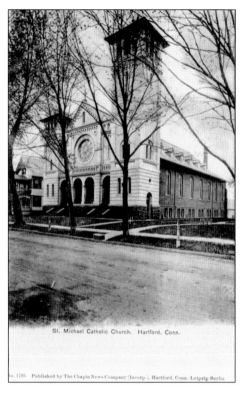

St. Michael Catholic Church. Hartford, Conn.

No. 1705 Published by The Chapin News Company (Incorp.), Hartford, Conn.-Leipzig-Berlin

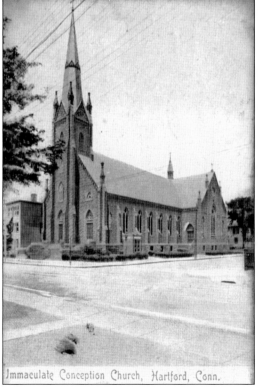

Immaculate Conception Church, Hartford, Conn.

The growing immigrant population necessitated a need for new churches to house the diverse ethnic backgrounds. The Immaculate Conception Roman Catholic Church's cornerstone was laid on October 21, 1894, and opened for worship on May 19, 1895. It was built on the corner of Park and Hungerford Streets. The church still stands but the congregation has merged with St. Anne's Roman Catholic Church.

43

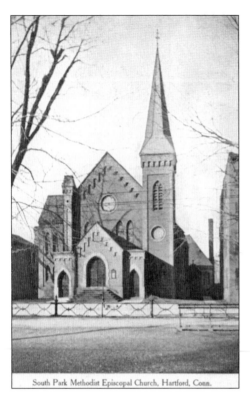

South Park Methodist Episcopal Church, Hartford, Conn.

James Jordan was the architect for the South Park Methodist Episcopal Church at 75 Main Street across from South Green (Barnard Park). It was organized in 1869 and dedicated on April 2, 1875. It once housed the Boardman Chapel, a Sunday school, and a 1,022-volume library. The Gothic Revival/Romanesque Revival church is now home to the South Park Inn, a shelter for the homeless.

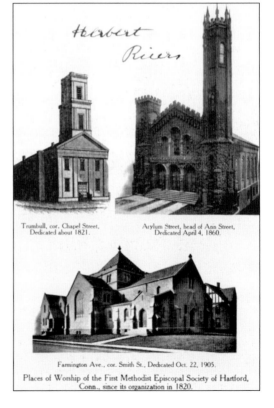

Trumbull, cor. Chapel Street, Dedicated about 1821.

Arylum Street, head of Ann Street, Dedicated April 4, 1860.

Farmington Ave., cor. Smith St., Dedicated Oct. 22, 1905.

Places of Worship of the First Methodist Episcopal Society of Hartford, Conn., since its organization in 1820.

Locations for the First Methodist Episcopal Society changed several times before landing on the corner of Farmington Avenue and Smith Street (South Whitney Street). It seated 550 worshippers, held a 500-volume library, and maintained a Sunday school. The Gothic Revival/Richardsonian Romanesque–inspired church still stands on the corner and is now known as the United Methodist Church.

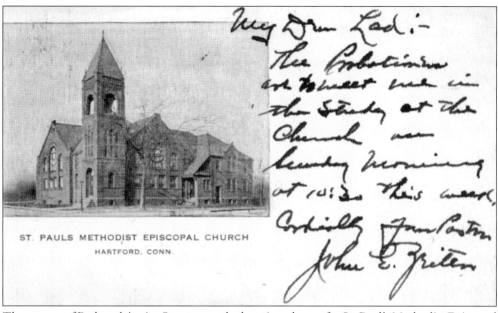

ST. PAULS METHODIST EPISCOPAL CHURCH
HARTFORD, CONN.

The corner of Park and Amity Streets was the location chosen for St. Paul's Methodist Episcopal Church. George W. Kramer was the architect for the Richardsonian Romanesque–styled building. It was organized on May 10, 1893, and dedicated on December 2, 1900. It is said that the church and Sunday school site lost the top third of its bell tower and its pyramidal roof in the Hurricane of 1938. The Hispanic-American Templo Sion Pentecostal congregation now calls this place home.

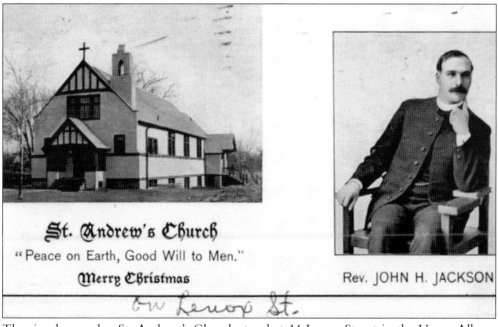

St. Andrew's Church
"Peace on Earth, Good Will to Men."
Merry Christmas

Rev. JOHN H. JACKSON

The simple wooden St. Andrew's Church stood at 14 Lenox Street in the Upper Albany neighborhood. Poindexter and Dowd were the developers of this neighborhood that exploded with construction when the trolley line was brought up through Albany Avenue. The site was near Keney Park and is now the Abundant Life Tabernacle Church.

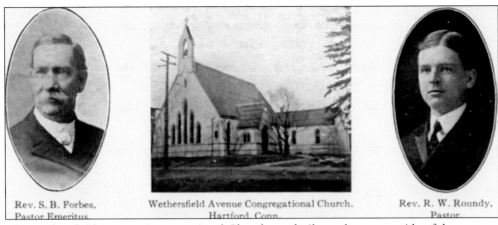

Rev. S. B. Forbes,
Pastor Emeritus.

Wethersfield Avenue Congregational Church.
Hartford, Conn.

Rev. R. W. Roundy,
Pastor.

The Wethersfield Avenue Congregational Church was built on the eastern side of the street at 250 Wethersfield Avenue in the south of Hartford. It faced Bliss and Adelaide Streets and was organized on May 28, 1873. The library contained 690 volumes, and a Sunday school was also on site. It was replaced by warehouses and offices. The recent commercialization of the street threatens the remaining historic charm of the area.

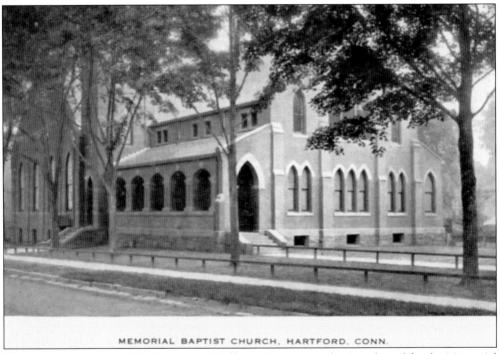

MEMORIAL BAPTIST CHURCH, HARTFORD, CONN.

The northwest corner of Washington and Jefferson Streets was the site selected for the Memorial Baptist Church. The church, which included a Sunday school, was organized on July 10, 1884, and incorporated November 19, 1889. The church has been demolished and replaced by an office building.

46

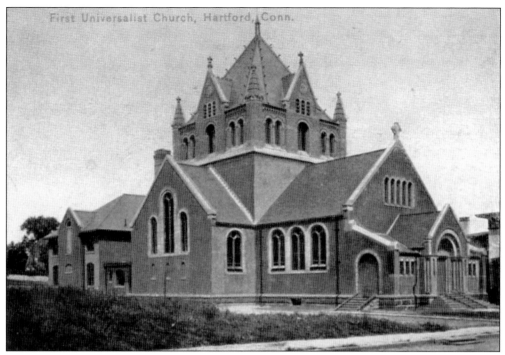

Asylum Street, at number 688, was the address of the First Universalist Church of the Redeemer. It was organized on June 18, 1827, and the cruciform-shaped building was dedicated in December 1906. It stood near the intersection with Garden Street and next to the American School for the Deaf. It did not survive the encroachment of the insurance companies that were making their way into the Asylum Hill neighborhood.

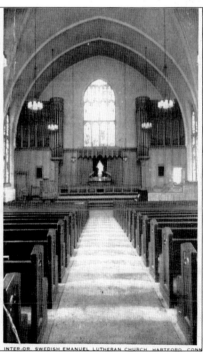

The Frog Hollow neighborhood became home to the multitudes of Hartford's new immigrants. The Scandinavians were some of the earliest arrivals. They built the Swedish Emanuel Lutheran Church. The simple yet inviting interior provided comfort for those so far away from their homeland.

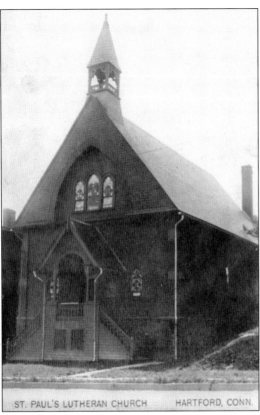

ST. PAUL'S LUTHERAN CHURCH HARTFORD, CONN.

Another parish established St. Paul's Lutheran Church. With dedicated hearts, the various ethnic groups in the city usually donated a portion of their hard-earned income and sometimes even provided the labor to build their respective churches, parish halls, and schools. The surviving buildings are a testament of their faith and devotion.

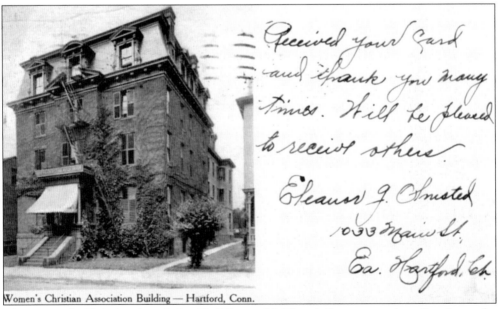

Women's Christian Association Building — Hartford, Conn.

The Women's Christian Association Building at 58 Church Street was a boarding house for women of the Christian faith. The association was organized on June 6, 1867, and incorporated in 1869. It was spearheaded by the leading society ladies of the day. There was also an industrial department next door at 54 Church Street and a young women's branch at 52 Church Street.

Polish immigrants settled heavily in the Charter Oak Avenue and Sheldon Street neighborhood. To complement their strong Roman Catholic faith a parochial school was founded. SS. Cyril and Methodius Church has survived the changes in the neighborhood and continues to be a beacon for those of Polish ancestry as well as others of the Catholic faith.

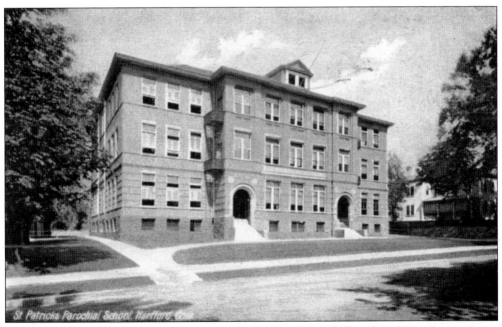

St. Patrick's Parochial School was constructed near the corner of Church and Ann Streets. It was a block away from St. Patrick's Roman Catholic Church on Church Street. It was demolished, and the site is now used for parking. This was a remedy all too often used in Hartford in the past decades.

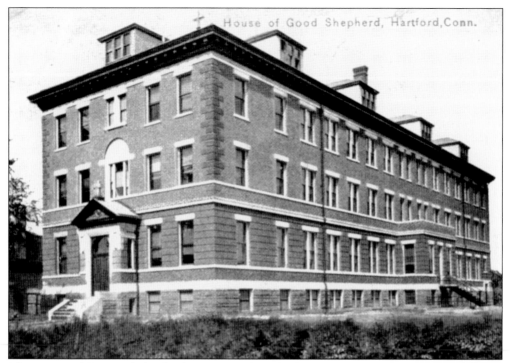

The House of the Good Shepherd was erected on the former estate of Albert Sisson on Sisson Avenue. When the Sisters of the Good Shepherd acquired the grounds in 1903 they gradually added buildings to the complex. The site is now used for elderly housing.

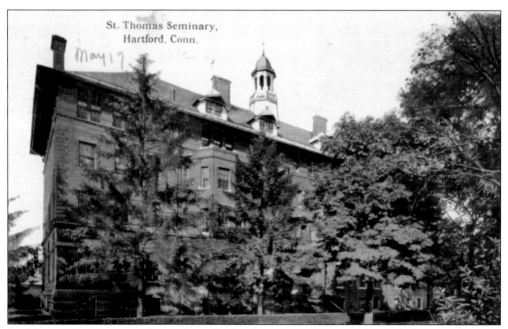

St. Thomas Seminary was located on Collins Street, on the grounds of St. Francis Hospital. This preparatory institution did not survive the rapid expansion of the hospital campus in the Asylum Hill neighborhood.

Five

HEALTH AND KNOWLEDGE

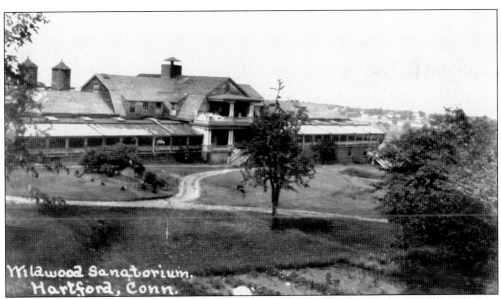

Wildwood Sanatorium, Hartford, Conn.

The Southwest neighborhood terrain was ideal for construction of the Wildwood Sanatorium. Located high above the city, the site, which included a farmhouse, was chosen for a tuberculosis hospital. The open air verandas were thought to aid recovery from the infectious disease that affected the lungs. The Avery Heights complex now occupies the land.

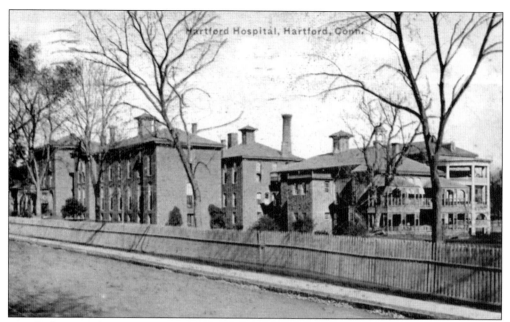

Hartford Hospital was founded in 1854 and was dedicated on May 19, 1859, with its official address as 20 South Hudson Street. Over the years, the hospital has greatly expanded, eliminating South Hudson Street and taking over the southern half of Seymour Street. All of the buildings pictured have been replaced.

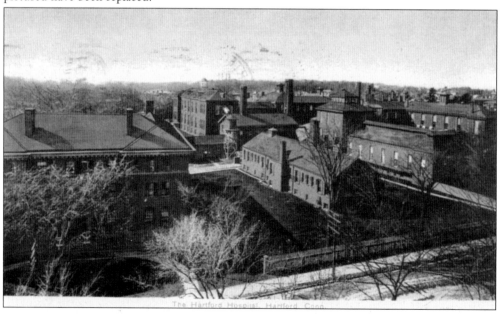

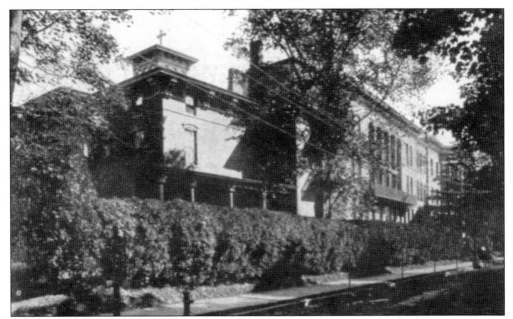

St. Francis Hospital was founded in 1897 by the Sisters of St. Joseph who came to Hartford from Chambery, France. The original hospital was established in the former home of Bishop Michael Tierney (left) on the corner of Woodland and Collins Streets. In 1899, the hospital began adding buildings to the campus to accommodate new services. St. Francis Hospital is now bounded by Woodland, Ashley, Collins, and Atwood Streets. The 1899 campus has been replaced by newer structures.

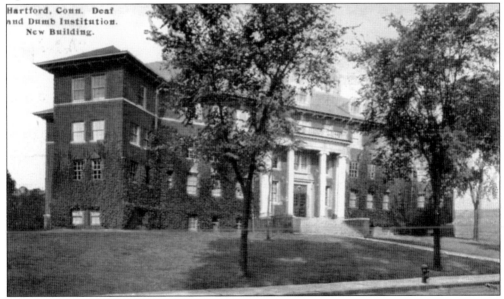

The American School for the Deaf was located on Asylum Street, which is how the street and neighborhood received their names. This Asylum Hill neighborhood building was added to the complex but was accessed from 65 Garden Street. It was next to the Hartford Water Works reservoir and was still standing in 1921 when the Hartford Fire Insurance Company built their headquarters after purchasing the site from the school. It has not survived.

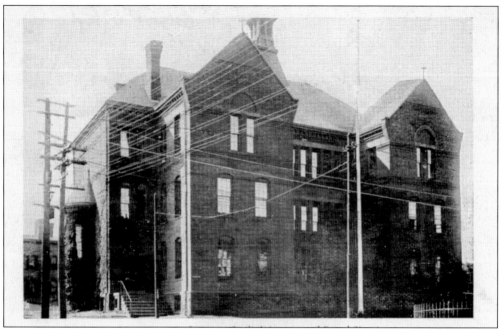

St. Joseph's School at 339 Capitol Avenue and the Cathedral Lyceum at 227 Lawrence Street were built to accommodate the Frog Hollow neighborhood's growing immigrant population. In 1923, the Lithuanian Roman Catholic Church of the Most Holy Trinity, 53 Capitol Avenue, purchased St. Joseph's School for use as its own school. It would become the first Catholic parochial high school in Hartford. The edifice had 18 rooms and a third floor hall and stage. The Lithuanian-American Citizens Club would also be established at the lyceum in 1940. In 1964, the Capitol Avenue and Broad Street school was closed and demolished for a gas station, a loss to the architectural landscape of the neighborhood.

Hartford, Conn., June 10, 1909.

Dear Associate:—

The sixth annual reunion of the Cathedral School Alumni Association will be held in Lyceum Hall, on June 24th.

These gatherings provide an excellent opportunity of renewing old acquaintances and it is desired that you be present in order that your friends may greet you.

The affair will be of a complimentary nature, and this invitation must be presented at the door.

Your school friends,

The Committee.

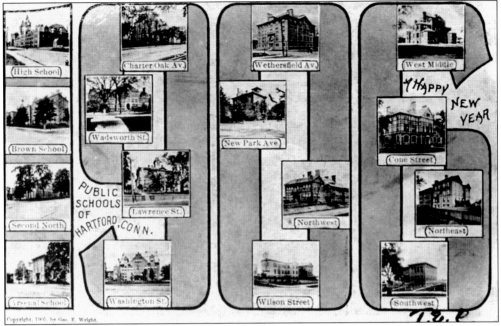

Hartford was known for its strong education system and well designed facilities. Hartford Public High School was the premier high school of its day, attracting students from around the country and even internationally. There are few reminders of the distinctive school buildings constructed to house Hartford's student population.

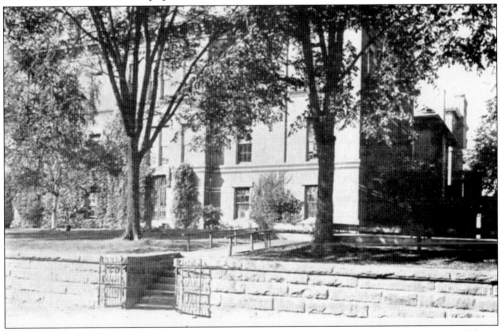

One of the buildings lost in the past 20 years was the 1878 Lawrence Street School. It had been expanded in 1895 by Hapgood and Hapgood and again in 1905. There was a striking Second Empire tower that enhanced the stately school located between Park and Grand Streets. A new school has been constructed on the site.

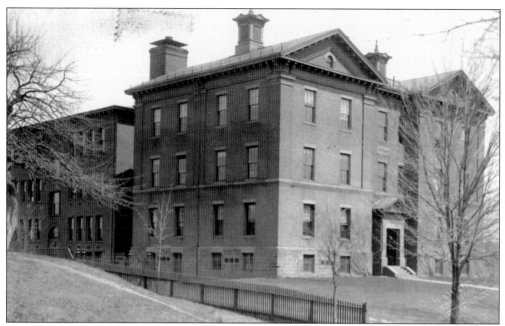

The Northeast District School was at 54 Westland Street. It was akin to the style of the Lawrence Street School. The school included a kindergarten and a 150-volume library. The New Park Avenue School in Parkville was located at 39–53 New Park Avenue between Park and Grace Streets. It was built in 1873 with two additions following in 1885 and 1896. The school, which had room for 950 students, held a 100-volume library.

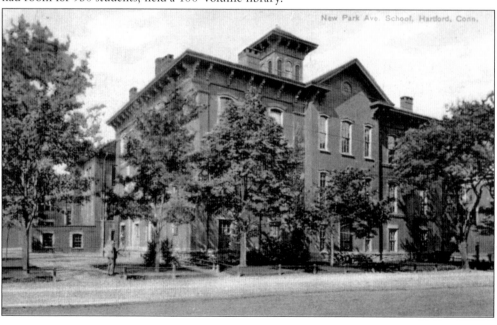

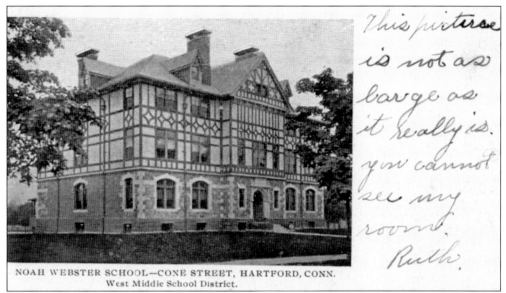

This picture is not as large as it really is. You cannot see my room. Ruth.

NOAH WEBSTER SCHOOL—CONE STREET, HARTFORD, CONN.
West Middle School District.

The Noah Webster School on Cone Street was built of Massachusetts seamless granite, Longmeadow red sandstone, mottled brick, and ordinary granite. It was occupied in the spring of 1901. The Tudor Revival building is in the heart of the West End neighborhood and surrounded by Whitney, Cone, and Tremont Streets.

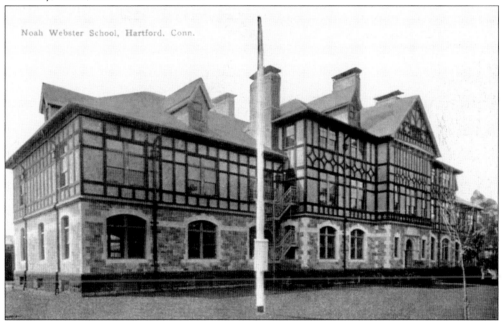

Noah Webster School, Hartford, Conn.

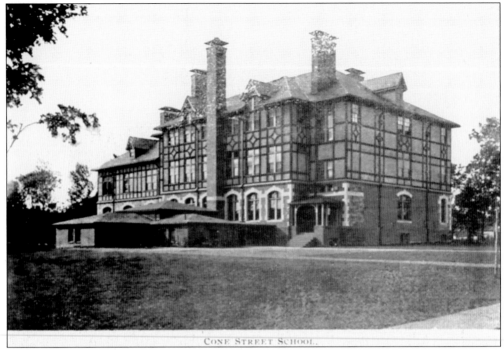

CONE STREET SCHOOL.

William C. Brocklesby is the architect listed for the design of the Noah Webster School. Many additions and alterations have taken place over the years, including one recently completed. This last renovation connected the separate buildings added by Brocklesby and Smith in 1906 and 1909 and the 1932 work of Malmfeldt, Adams, and Prentice.

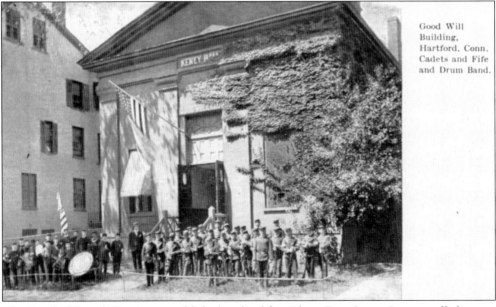

Good Will Building, Hartford, Conn. Cadets and Fife and Drum Band.

The Hartford Female Seminary established a school for girls on Pratt Street. It eventually became Keney Hall and home to the Good Will. The building provided space for groups such as the Cadets and Fife and Drum Band. It did not survive the addition of large commercial buildings to the street.

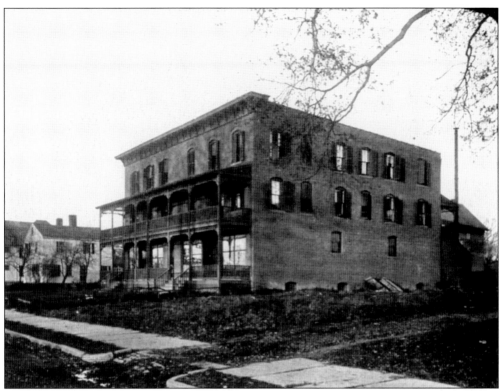

The Industrial Home of the Connecticut Institute for the Blind was on Wethersfield Avenue and Meadow Road (Airport Road). The building's last incarnation was as Carmichael's Restaurant. Efforts to convince a national drugstore chain to incorporate the structure into their designs were unsuccessful, and it was demolished.

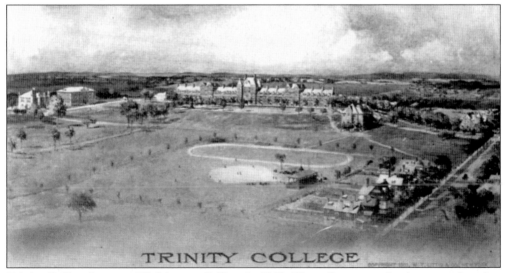

TRINITY COLLEGE

Trinity College began as Washington College in 1823. The college moved to its present location when the Capitol Avenue campus was purchased by the state for the site of the new state capitol building. The new college campus quickly expanded to include new facilities including a baseball field and grandstand.

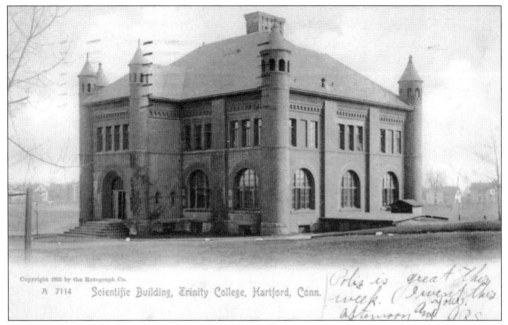

A 7114 Scientific Building, Trinity College, Hartford, Conn.

One of the first new buildings to be added to the Trinity College campus was the Jarvis Scientific Laboratory Building, completed in 1888 to the design of Josiah Cleveland Cady. It had been donated by George A. Jarvis of Brooklyn, New York. It served studies in chemistry, physics, and engineering until it was demolished in 1963 for the Austin Arts Center.

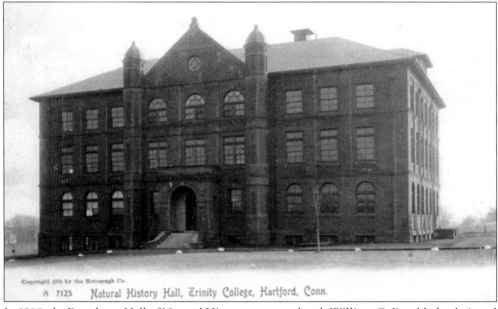

A 7123 Natural History Hall, Trinity College, Hartford, Conn.

In 1900, the Boardman Hall of Natural History was completed. William C. Brocklesby designed the new building, which housed the biology department and a museum. It had been a gift of Lucy H. Boardman but was demolished in 1971.

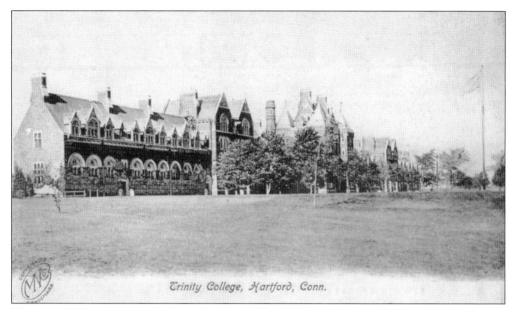

Trinity College, Hartford, Conn.

The year 1898 saw the completion of Trinity College's famous Long Walk, a 600-foot-long walk connecting Seabury, Northam, and Jarvis Halls. It has been stated that Trinity College has one of the best examples of Victorian Gothic Collegiate architecture.

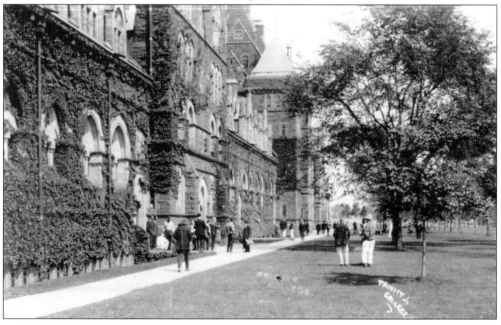

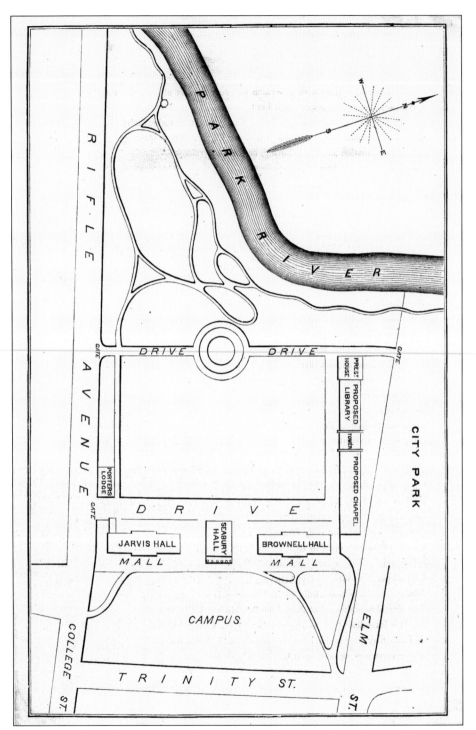

This 1867 map shows the Trinity College campus when it was located on Rifle Avenue and College Street (both now Capitol Avenue). There were proposals for new construction on Elm Street but they never materialized. The college moved to Summit Street to the dismay of many students who did not wish to be so far removed from the city center.

Six

REFLECTIONS

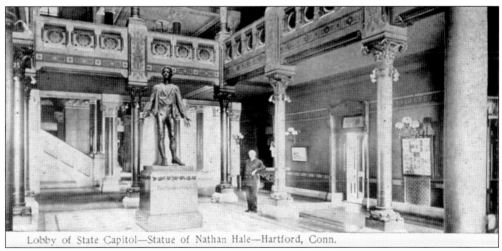

Lobby of State Capitol—Statue of Nathan Hale—Hartford, Conn.

The new state capitol that rose on the site of Trinity College's former campus is one of the most spectacular in the country. There are many statues stationed in the interior and placed on the exterior grounds. Nathan Hale is Connecticut's state hero. He became a spy for Gen. George Washington during the Revolutionary War. He was captured and hanged by the British, with his last words being "I only regret that I have but one life to lose for my country."

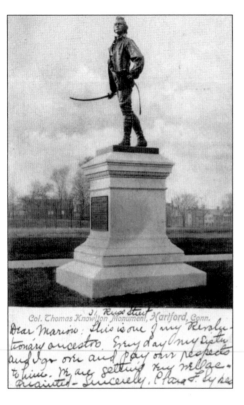

Col. Thomas Knowlton's bronze statue was commissioned by the general assembly in 1893. The granite-based statue rests on the capitol lawn. Knowlton was chosen to command the Continental Army's first intelligence unit. Nathan Hale was one of the unit's first spies.

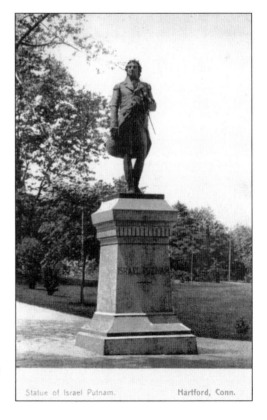

Israel Putnam's statue, created by J. Ward, was placed in Bushnell Park to honor the American army general. He had fought with distinction at the Battle of Bunker Hill in 1776.

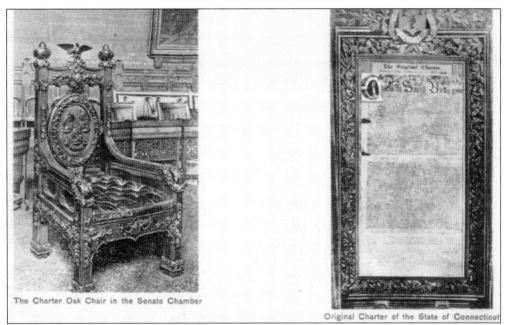

The Charter Oak Chair in the Senate Chamber

Original Charter of the State of Connecticut

The Charter Oak Chair was carved from the famous fallen oak tree that had hidden the self-governing charter granted to the colony by King Charles II in 1662. When an emissary was sent to retrieve the charter it disappeared and was placed in the tree. Since so many items have been purported to be made from the tree, from the smallest trinket to pianos and walls, they should be viewed with caution and a bit of skepticism.

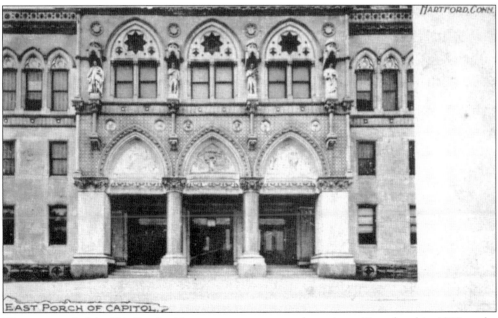

The state capitol itself is lined with numerous statues and carvings. Completed in 1878 to the designs of Richard M. Upjohn, it is one of the finest examples of High Victorian Gothic. It was listed in 1971 as a national historic landmark and has undergone several restorations.

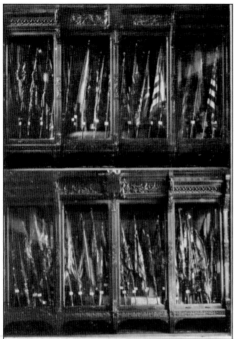

BATTLE FLAGS OF CONNECTICUT.
Colors" of the thirty Connecticut regiments in the War of the Rebellion 1861-65, deposited in the State Capitol on "Battle Flag Day," September 17, 1879, by their surviving followers, when Hartford, then a city of about 43,000 persons, entertained some 50,000 visitors.

Back inside the capitol, through the West Atrium one encounters the Hall of Flags. Battle flags of the Connecticut regiments from the Civil War hang in oak cases built especially for their display. They were placed there to great fanfare in 1879. In the center of the hall is the statue of William Buckingham, governor of Connecticut during the Civil War. Buckingham Street is named after him.

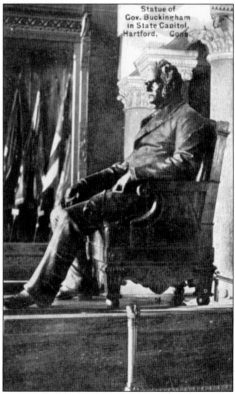

Statue of Gov. Buckingham in State Capitol, Hartford, Conn.

Scene in Bushnell Park, Hartford, Conn.

This rare view deceives the viewer. It actually shows only one side of the Soldiers and Sailors Memorial Arch that spans Trinity Street in Bushnell Park. George Keller, whose remains were placed in the east tower, designed the city landmark. It was dedicated on September 17, 1886.

The Campfield Green monument to Gen. Griffin A. Stedman honors the memory of the 26 year old who had just been promoted to general when he was mortally wounded on August 5, 1864. The green, a camping and mustering-in point during the Civil War, was chosen as the site to unveil his statue on October 4, 1900. It stands gallantly where Maple and Campfield Avenues converge.

Gen. Griffin A. Stedman, Hartford Conn.

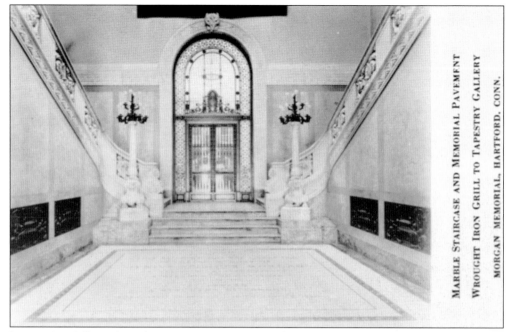

International financier John Pierpont Morgan was born in Hartford in 1837. By the time of his death in 1913, he had amassed quite a fortune. He provided the funds to erect the Spencer Morgan Memorial wing, an addition to the Wadsworth Atheneum. These two views show the dual marble staircase and entrance to the tapestry hall.

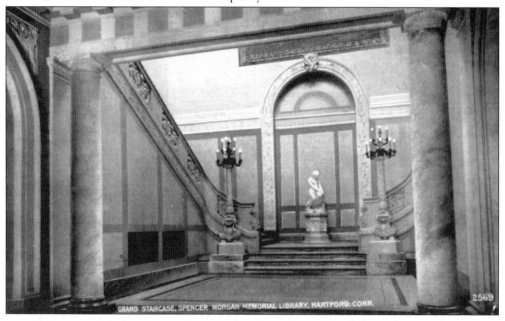

GRAND STAIRCASE, SPENCER MORGAN MEMORIAL LIBRARY, HARTFORD, CONN. 2569

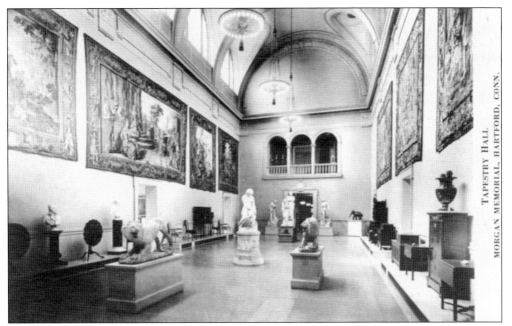

Morgan's generosity also provided the land for the addition that had been purchased from St. John's Church. The edifice was constructed with Knoxville granite and connected to the Colt Memorial wing that had been added earlier in 1905. The tapestry hall remains a great venue for events.

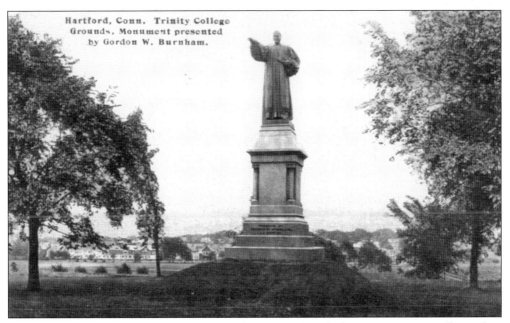

Episcopal bishop Thomas Church Brownell is credited with forming Trinity College, then Washington College, in 1823. He became its first president in 1824 and served until 1831. His statue looks over the college campus to this day.

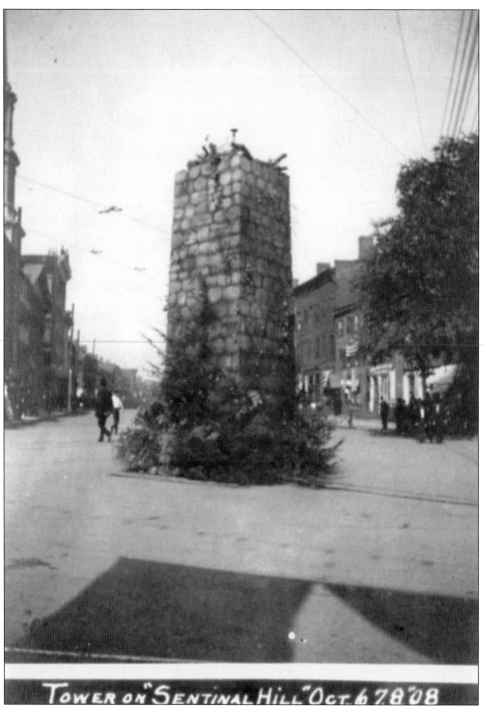

TOWER ON "SENTINAL HILL" OCT. 6 7 8 '08

In celebration of the years long construction of the stone bridge that traversed the Connecticut River, major events took place on October 6–8, 1908. A tower was built near the intersection of Main, Morgan, and Windsor Streets to commemorate the location of the city founders' outpost that had been built to take advantage of the high elevation. Morgan Street was the entryway to the new engineering marvel that crossed the river.

Seven

VISITING THE
CAPITAL CITY

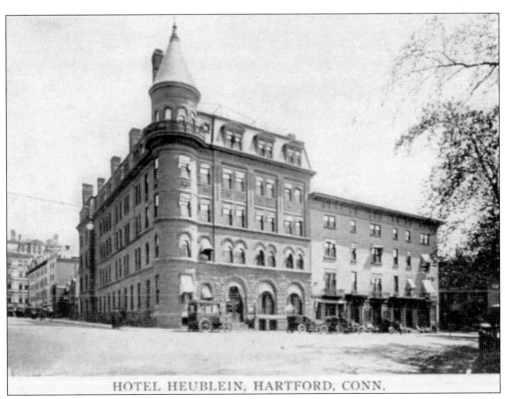

HOTEL HEUBLEIN, HARTFORD, CONN.

The turreted Hotel Heublein was built across from the Park River and Bushnell Park. Unfortunately the 98 Wells Street hotel was demolished in 1965, a casualty of urban renewal, a failed scheme to revive the city. The scars have yet to heal.

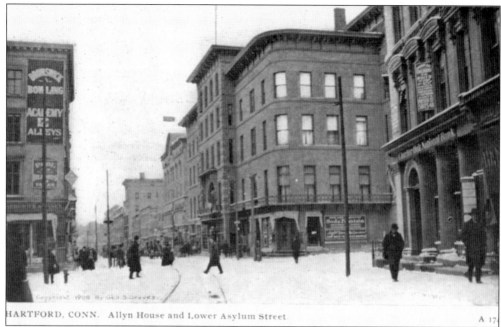

The Allyn House Hotel was built on the corner of Asylum and Trumbull Streets. The iconic hotel's most famous guest was Pres. Abraham Lincoln. Descendants of the original proprietor still own the bed he slept in. The incredible marble work, rich woods, and massive lobby fireplace were not spared by the wrecker's ball.

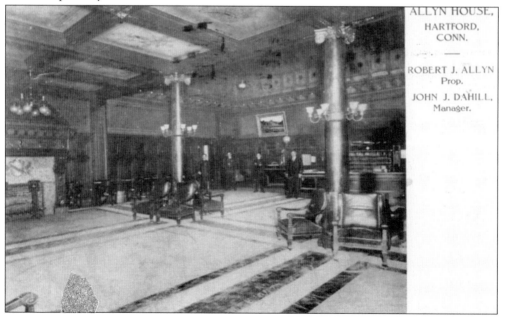

ALLYN HOUSE,
HARTFORD,
CONN.

ROBERT J. ALLYN
Prop.

JOHN J. DAHILL,
Manager.

UNION HALL HOTEL,

Hartford, Ct., Nov. 1878.

Dear Sir :

 We respectfully solicit your patronage at our Hotel, situated at No. 9 Farmington Avenue, five minutes walk west from the Depot; first-class table, pleasant and comfortable rooms; this Hotel is heated by one of Pitkin Bros. fifty horse power steam boilers.

 TERMS TO MEMBERS OF THE LEGISLATURE: *$1.25 and $1.50 per day, or $7.00 to $10.00 per week. according to location of rooms.*

 The Horse Cars pass the door every fifteen minutes.

 Yours respectfully,

E. E. CALLENDER, Manager.

The Union Hall Hotel advertised itself in 1878 as a convenient location, just down the street from Union Station. There were even special rates for members of the state legislature. Hartford and New Haven were once dual capitals until Hartford emerged as the sole center of government, which brought even more activity to the city.

United States Hotel,

HARTFORD, CONN.

D. A. ROOD, PROPRIETOR.

State Street was the location of the United States Hotel, one of the oldest in the city. Those who came to the city on business found it an excellent location since it was across the street from the Old State House, which was used as city hall.

WINE LIST.

CHAMPAGNE.

	Pints.	Quarts.
Henriot & Co.	$1 50	$3 00
Piper & Co., Heidsick	1 50	3 00
Mumm's Dry Verzenay	1 50	3 00
Rœderer's Dry Sillery	1 50	3 00
Rœderer's Carte Blanche	1 75	3 50

CLARET.

St. Laubes	75	1 25
St. Julien	50	1 00
St. Julien, Barton & Guestier	75	1 50
Puaillac, Brandenburg Freres	75	1 25

SHERRY.

Topaz	2 00
Imperial	2 50

PORT.

Burgundy Port	2 50

SAUTERNE.

Haute Sauterne	75	1 50

HOCK.

Laubenheimer	1 50

SUNDRIES.

Cabinet Whiskey	2 00
Rye Whiskey	2 00
Brandy, Henessey	3 00
Brandy, Otard	4 00
Brandy, Henessey, 1848	4 50
Bass' Pale Ale	30
Extra Stout	30
Russet Cider, Park & Tilford	25
Scotch Ale	25
Smith's Philadelphia Ale	20

The wide selection of libations offered by the hotel was enjoyed by the weary traveler or city resident. Special merit was given to the vintage 1848 Henessey Brandy.

BILL OF FARE.

Thursday, February 10th, 1881.

SOUP.

Mutton Broth, with Barley.

FISH.

Boiled Cod, Butter Sauce.

BOILED

Beef Tongue.

Corned Beef, with Cabbage. Mutton, Caper Sauce.

ROAST.

Lamb. Loin of Pork, with Apple Sauce. Ribs of Beef.

Saddle of Venison, with Currant Jelly. Turkey, Cranberry Sauce.

ENTREES.

Chicken Fricassee, a la Poulet.

Sirloin of Beef, braise, Sauce Champignon.

Rice Cake, glasse, au Jelly.

There was room service in the Hartford of 1881. Meals, fruit, and nuts could be sent to a room for

76

RELISHES.

Worcestershire Sauce. French Mustard. Leicestershire Sauce
Tomato Catsup. Crosse & Blackwell's Pickles.
Cranberries. Halford Sauce. Pickled Beets
Celery. Shaker Apple Sauce.

VEGETABLES.

Boiled Rice. Potatoes. Mashed Potatoes
Stewed Tomatoes. Squash. Onions.
Cabbage. Turnips. Succotash

PUDDING AND PASTRY.

Steamed Indian Pudding, Rum Sauce.
Stewed Apple Pie. Mince Pie. Prune Pie
Orange Layer Cake. Sponge Drops.

DESSERT.

Vanilla Ice Cream.
Almonds. Florida Oranges. English Walnuts. Apples. Raisins

COFFEE. TEA.

Meals, Fruit, Nuts, &c., sent to rooms, charged extra.

an extra charge. Although menus might have changed, the bill of fare shows quite an offering.

Nook Farm,
Hartford, Conn.

May 4 1893

My Dear Mrs Goss

Many thanks for
your inquiries concerning
Howells. If he keeps on
— and I hope he will —
you ought to be able to write
a history of American art
of his titles

Yours sincerely

Chas Dudley Warner

Samuel L. Clemens, better known as Mark Twain, visited and fell in love with the literary city. He would have stayed in one of Hartford's posh hotels if not at a friend's home, such as Charles Dudley Warner's. Warner even created his own stationary as mementos to those who had visited or been in correspondence with him. He was Twain's editor, coauthor, and close friend.

78

Eight

ESTATES

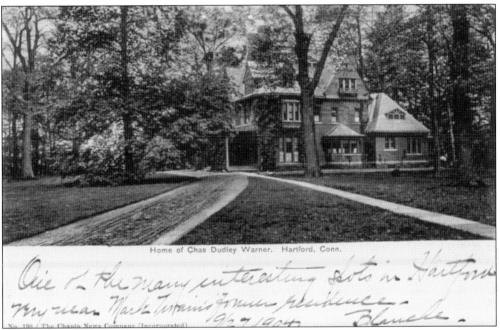

Charles Dudley Warner's home was nestled in a grove of towering trees on Forest Street in the Nook Farm neighborhood off of Farmington Avenue. The estates of some of Hartford's illustrious literary community were built along the nook of the Park River that flowed by. Urban renewal reached Nook Farm in the 1960s. Warner's house and many of his neighbors' homes were lost.

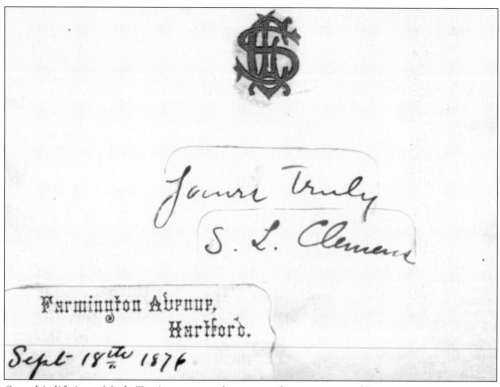

Yours Truly
S. L. Clemens

Farmington Avenue,
Hartford.
Sept 18th 1876.

Over his lifetime, Mark Twain composed a tremendous amount of letters written to family, friends, fans, and business associates. Major collections of his correspondence have been amassed by universities, literary institutions, museums, and private collectors.

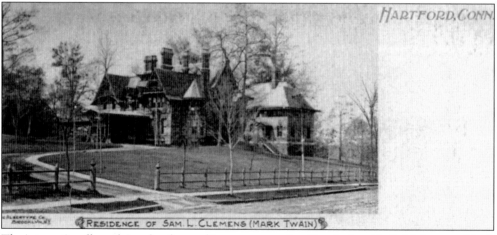

The internationally acclaimed author and inventor moved to Hartford and built his home at Nook Farm in 1874. This national historic landmark was designed by Edward Tuckerman Potter in association with Alfred H. Thorp. Many of the interior rooms were the work of Louis Comfort Tiffany and Associated Artists.

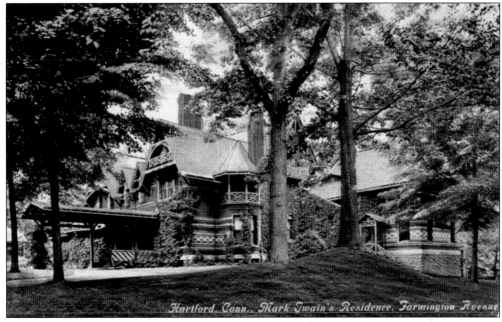

Hartford, Conn., Mark Twain's Residence, Farmington Avenue

Twain and his family lived in their cherished home until 1891, selling it in 1903. It has been compared to a mix of Swiss chalet, river steamboat, and cuckoo clock. Recent restorations have reopened the kitchen wing for viewing, and a new museum facility addition has greatly added to the visitor experience.

For Sale—Hartford, Conn.

Homestead of the late Miss Ellen M. Case. Seven (7) acres situate on Farmington Avenue, one mile west of Railroad Station. Brick dwelling every way modern and in complete order. Greenhouse, Gardener's Cottage, Stable and House for Coachman.

The departure of Twain in 1891 and the death of Harriet Beecher Stowe in 1896 indicated the slow dissolution of what had been such a vibrant community. The Ellen M. Case estate on the corner of Farmington Avenue and Forest Street was another sign of the changing times.

J. M. GALLUP & CO.

invite the critical attention of the discriminating listener to the EVERETT Piano, played by Gabrilowitsch.

Unity Hall on Pratt Street welcomed Russian-born Ossip Gabrilowitsch in 1901. The accomplished pianist toured widely in Europe and the United States. In 1909, he married Clara Clemens,

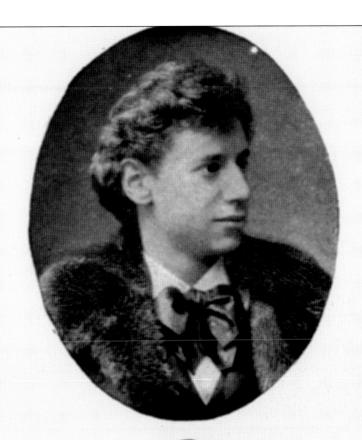

Ossip Gabrilowitsch.

UNITY HALL,

HARTFORD.

concert singer and daughter of Mark Twain. She would be the only child to outlive her famous father but left no living descendants.

UNITY HALL, HARTFORD.

Ossip Gabrilowitsch Piano Recital.

WEDNESDAY EVENING, MARCH 13, 1901,
at 8 o'clock.

PROGRAM.

1. BEETHOVEN—
 Sonata, A-flat major (Op. 110).
 Moderato cantabile molto espressivo.
 Allegro molto, Adagio, ma non troppo (Arioso dolente).
 Fuga (Allegro, ma non troppo).

2. BRAHMS—
 Variations and Fugue on a
 Theme by Händel (Op. 24).

3. CHOPIN—
 Prelude, D-flat major.
 Etude, C major.
 Ballade, G minor.

4. RACHMANINOFF—
 Serenade (Op. 5).

5. GABRILOWITSCH—
 Caprice-burlesque.

6. LIADOW—
 Prelude, G major.

7. SCHUBERT–TAUSIG—
 Marche Militaire.

The Piano is an Everett.

BELONGI
Ossip (
transmigratio
has certainly
ter, Anton Ru
the musical w
mental, intell
supreme trini
ability. An
so recognized
latter's death
phrase of Os
horses of Ru

"Raconteur"-
Gabrilow
chord which
The North
witsch is a
in Gogol.
politan Rus
acquainted
ing, back of
fonds of the
upon a Tart
this Duke o
cultivated g

W. F. Apthor
A clear,
ous, but ne
sense, these
young pian
dominant i
fully unders
ing clear as
short he is a

BRILOWITSCH.

to the royal line of Rubinstein,
rilowitsch is a living exemplar of the
f artistic souls. This young Russian
erited the God-like genius of his mas-
stein ; no other pianist in the blaze of
d can exhibit such evidences, tempera-
ual and technical; displaying in this
of gifts the letters-patent of musical
stic son of Rubinstein he is, and was
the old Muscovite Giant. Since the
o employ the singularly expressive
Bie, Ossip Gabrilowitsch "drives the
tein !"

New York Musical Courier:

ch ! Here is a name whose letters form a
stantly transposes your ideas to another key.
es into view, but another North. Gabrilo-
ian you might meet in Turgenev, but never
is the modern, complicated, subtle cosmo-
a, the one who speaks every language, is
a every idea ; yet back of his Teutonic train-
Gallic culture, are the deep and inaccessible
. They say scratch a Russian and you come
Scratch Gabrilowitsch – I ask his pardon for
gyll simile—and you reach the cuticle of a
eman.

Boston Transcript :

ile technic ; a firm, sonorous touch - sonor-
noisy—above all, an impeccable rhythmic
the qualities which first strike you in this
Fire, warmth, grace he has, too, but the
ession you get from his playing is that he
ds everything he does and makes its mean-
y to you. He has apparently no tricks—in
tist one would fain hear again and often.

The Russian American pianist and
conductor had his debut in Berlin
in 1896 after having been a pupil in
St. Petersburg and Vienna. Although
he and his wife Clara Clemens
moved to Europe, she strove to
preserve her father's persona and
recorded the family's early life in
Hartford, which aided in the initial
restoration of her childhood home.

85

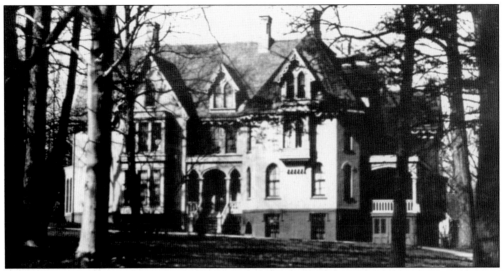

One of the first homes constructed in Nook Farm was the home of Harriet Beecher Stowe's half sister Isabella Beecher and her husband John Hooker. The 1861 Octavius J. Jordan–designed estate once ran all the way to Laurel Street. It is now hidden from view by the highway and by apartments that were built on its front yard.

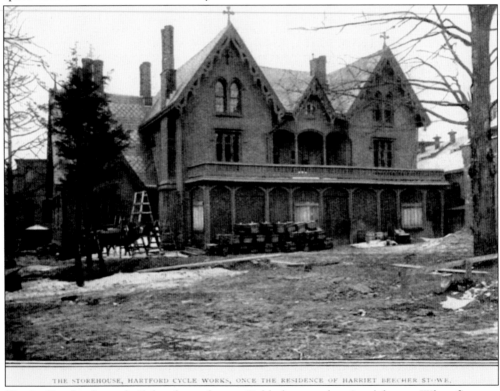

THE STOREHOUSE, HARTFORD CYCLE WORKS, ONCE THE RESIDENCE OF HARRIET BEECHER STOWE.

Harriet Beecher Stowe built her dream house, Oakholm, near her sister's house. When finances and the encroaching factory district proved too burdensome, she moved down the street to smaller accommodations. One must wonder what she might have written if she had seen what became of her beloved first home after her death.

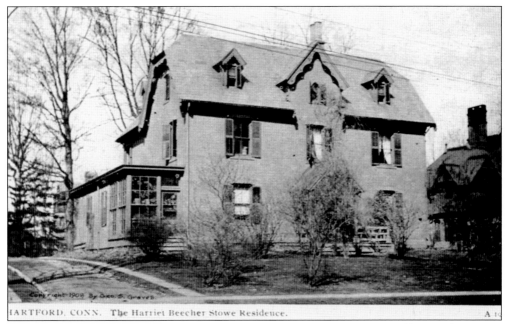

HARTFORD, CONN. The Harriet Beecher Stowe Residence. A 10

Although Oakholm did not survive, her second Hartford home, also a national historic landmark, was saved by her grandniece Katharine Seymour Day. The 1871 structure was occupied by the Stowe family in 1873. The Gothic Revival residence has been restored and is open to the public for an intriguing look into the life of the author of *Uncle Tom's Cabin*.

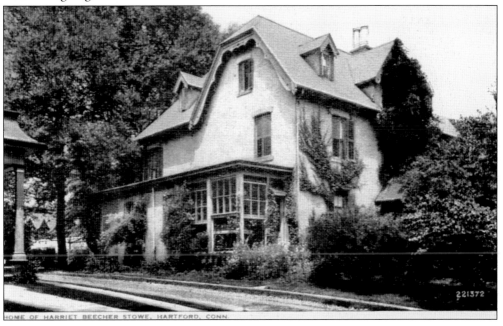

221372

HOME OF HARRIET BEECHER STOWE, HARTFORD, CONN.

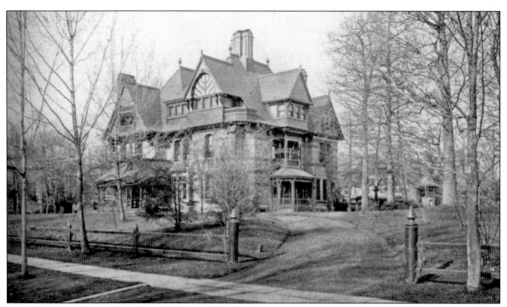

Harriet Beecher Stowe's new neighbor became Franklin Chamberlain when he built his 1881 Francis H. Kimball–designed home on the corner of Farmington Avenue and Forest Street. It was next to the Stowe house he had built earlier and the land he had sold to Mark Twain. Katharine Seymour Day also saved this Queen Anne–inspired residence from demolition, and it is now home to the Harriet Beecher Stowe Center, which maintains a great library and research facility.

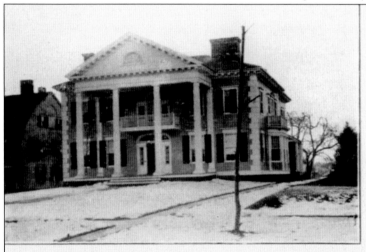

The Colonial Revival style had made inroads into the very Victorian neighborhood when this home arose on Forest Street. It was built for the John R. Buck family and was located near the northwest corner of Forest and Hawthorn Streets across from the Hooker homestead.

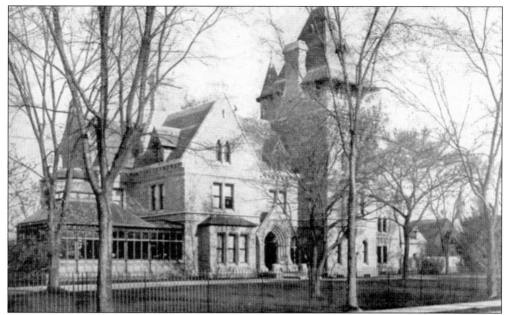

"The Castle" was the home of James J. Goodwin. He and his brother Francis, who had his own house built next door, were from one of the wealthiest families in the city. An amateur architect and instigator of city parks, Francis had drawn some sketches for the imposing residence originally commissioned by his father. However, recently uncovered documents show it to possibly be the work of William C. Brocklesby. The mansion at the northwest corner of Asylum Avenue and Woodland Street did not survive past the 1940s. One of the parlors has been installed at the Wadsworth Atheneum.

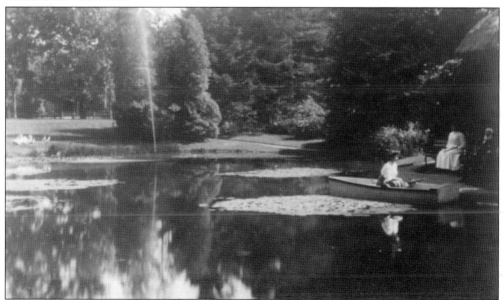

One of Hartford's grand estates even had a private pond. Pliny Jewell, a member of the prominent manufacturing and political family, established his private grounds at 210 Farmington Avenue in the center of the block surrounded by Laurel, Niles, and Sigourney Streets. The frontage bordered both Farmington Avenue and Niles Street.

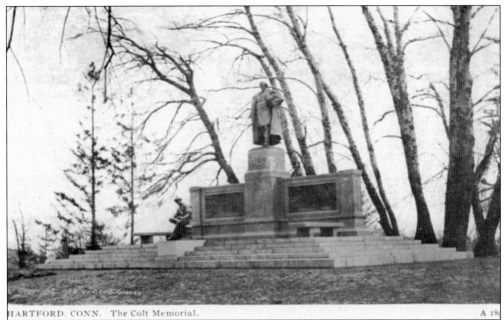

HARTFORD, CONN. The Colt Memorial. A 18

Samuel Colt put Hartford on the map. His incredible genius and innovation thrust the capital city into the international news. As a reminder of her husband's great accomplishments, Elizabeth Colt commissioned J. Massey Rhind in 1905 to create a monument to her husband for her Armsmear estate. The great sculptured work, which depicts a boy with a dream to a man with riches, is now a part of Colt Park.

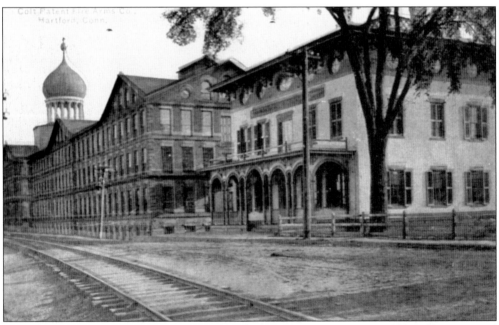

His life was cut short in the midst of the Civil War and his great armory would burn by suspected southern sympathizers, but his saga has lived on to tell an incredible story. Attempts to create a Coltsville National Park will again bring Hartford into the international limelight.

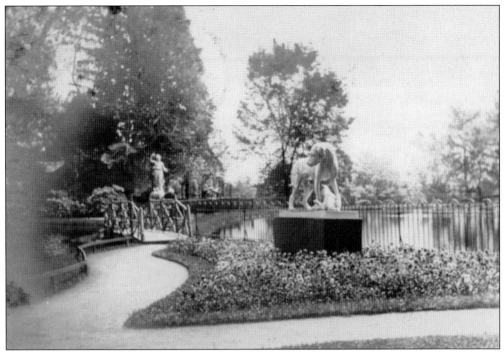

The Colt estate, Armsmear, was the result of fame and fortune. It was filled with marble statues, greenhouses, orchards, lakes, stables, and exotic fauna. The splendor created would soon disappear with the death of Elizabeth Colt in 1905. The mansion was converted into housing for Episcopal widows and the grounds became a city park. As of 2007, 18 acres of the park will soon become the Hartford Botanical Garden. The Connecticut Creative Store, on the former estate, sells Connecticut made products and the profits will help fund the project.

Rectory of the Church of the Good Shepherd — Hartford, Conn.

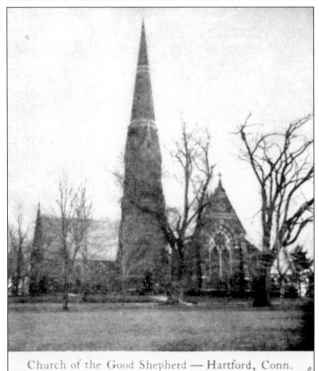

Church of the Good Shepherd — Hartford, Conn.

Elizabeth Colt's bequests have benefited and beautified the city. She outlived her husband and all of her children. She immortalized them with the Colt wing at the Wadsworth Atheneum, the Caldwell Colt Memorial Parish House, and the Church of the Good Shepherd. Her generosity as a patron of the city has never been matched.

Nine

ENTERTAINMENTS
AND AMUSEMENTS

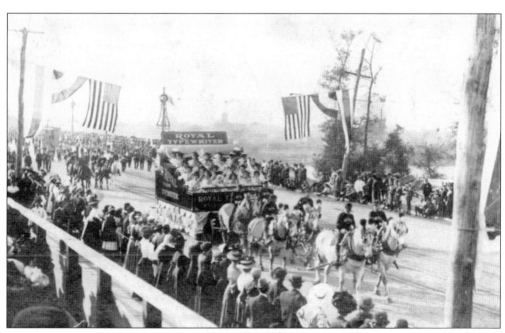

Hartford was not only labeled the insurance capital of the world but the typewriter capital as well. The mammoth Royal and Underwood factories produced units that were exported worldwide. Royal participated in the opening of the new stone bridge in October 1908. Their float was cleverly made up of workers wearing caps topped with letters, indicating the keystrokes on the typewriter.

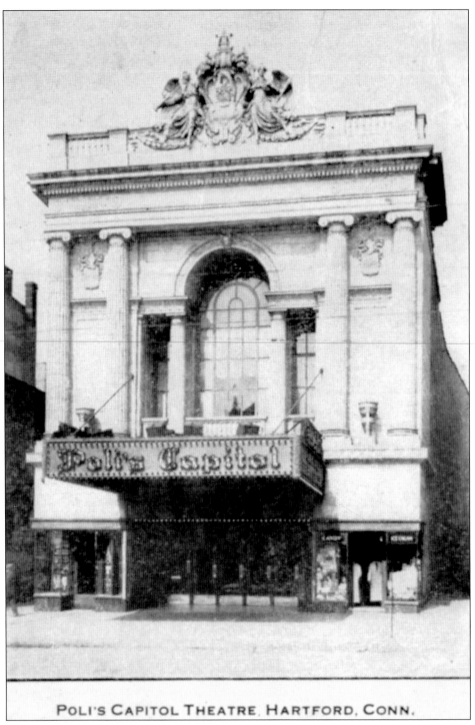

POLI'S CAPITOL THEATRE, HARTFORD, CONN.

Poli's Capitol Theater was a spectacular theater on Main Street between Wells and Mulberry Streets. A marble lobby, chandeliers, and velvet drapes gave quite the dramatic look to the interior spaces. Hartford lost all of its splendid theaters to the revitalization that hit the city in the 1960s and 1970s.

94

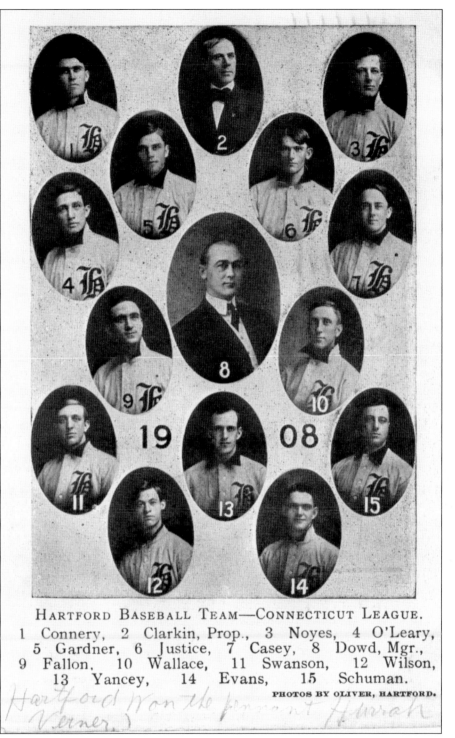

HARTFORD BASEBALL TEAM—CONNECTICUT LEAGUE.
1 Connery, 2 Clarkin, Prop., 3 Noyes, 4 O'Leary,
5 Gardner, 6 Justice, 7 Casey, 8 Dowd, Mgr.,
9 Fallon, 10 Wallace, 11 Swanson, 12 Wilson,
13 Yancey, 14 Evans, 15 Schuman.

Hartford won the pennant Hurrah
Verner.)

Baseball quickly became a national pastime. Hartford was in the forefront of the sport, popular with Trinity College students, professional leagues, and novices. There were ball fields scattered throughout the city, including one of the earliest in Coltsville in the 1870s.

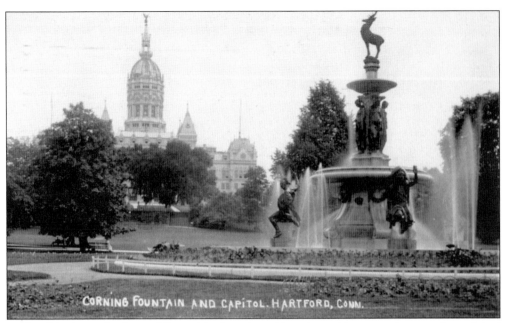

CORNING FOUNTAIN AND CAPITOL. HARTFORD, CONN.

Bushnell Park was the first public park in America where city residents voted to spend municipal funds to create a park. The year was 1854, but it was not until 1861 when Jacob Weidenmann was engaged for the project. Weidenmann also designed the grounds of the Butler-McCook home on Main Street, which is open to the public. The 1899 Corning Fountain was sculpted by J. Massey Rhind who would sculpt the Colt Monument at Armsmear.

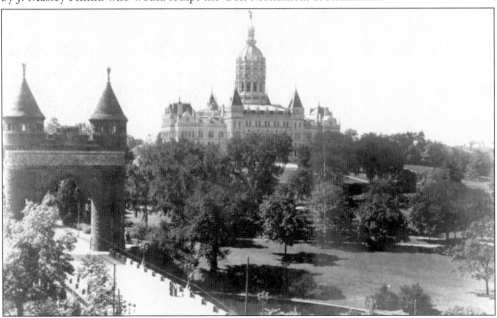

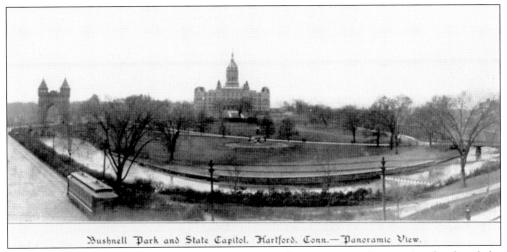

Bushnell Park and State Capitol. Hartford. Conn.—Panoramic View.

Before Bushnell Park was laid out, it was an area of tenements and tanneries that lined the banks of the Park River. This river has also been called the Little River, Hog River, and even Meandering Swine, an indication of what occurred in the vicinity. Weidenmann's improvements surely aided in the decision to place the new state capitol there.

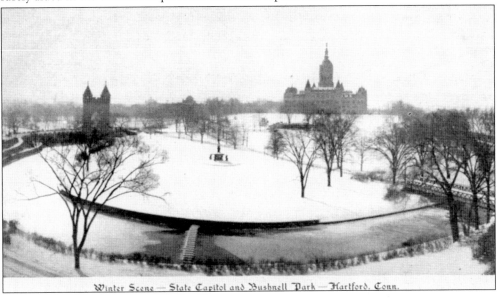

Winter Scene — State Capitol and Bushnell Park — Hartford. Conn.

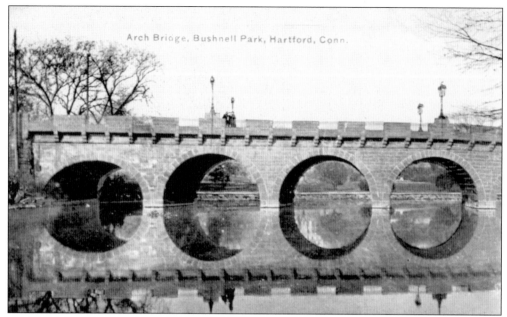

For centuries, Hartford has been devastated by the flooding of the Park and Connecticut Rivers. After the disasters of the 1936 flood and the 1938 hurricane, portions of the Park River were buried, and a dike was built along the Connecticut River. The many bridges that had spanned Bushnell Park were destroyed with the burial, with parts of them reassembled into park walls and the Pump House, which continues to protect the downtown from flooding.

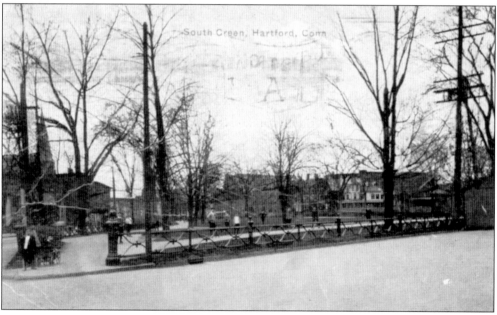

South Green, Hartford, Conn.

South Green is one of the few reminders left of a Colonial Hartford. It was first used for cattle grazing and military drills. Jacob Weidenmann designed a Victorian park on the site, surrounded by an ornamental fence, in the 1860s. Only a portion of the fence remains and the once inviting park has fallen on hard times, although there are current renewal efforts being made.

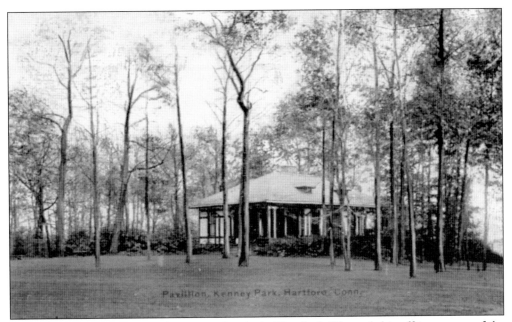

Francis Goodwin instigated the reign of parks in Hartford. Through his efforts, many of the parks are still enjoyed today and were created by his determination to beautify the capital. One of those established was Keney Park in 1896. It contains 693 acres and crosses into Windsor. The Olmsted firm was hired to design the scenic parkland.

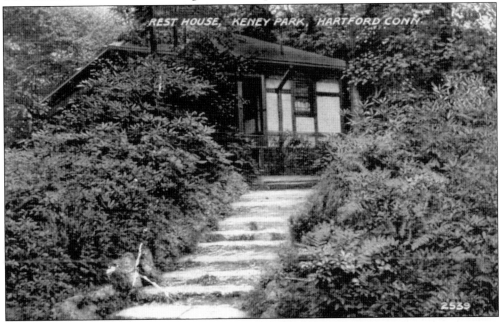

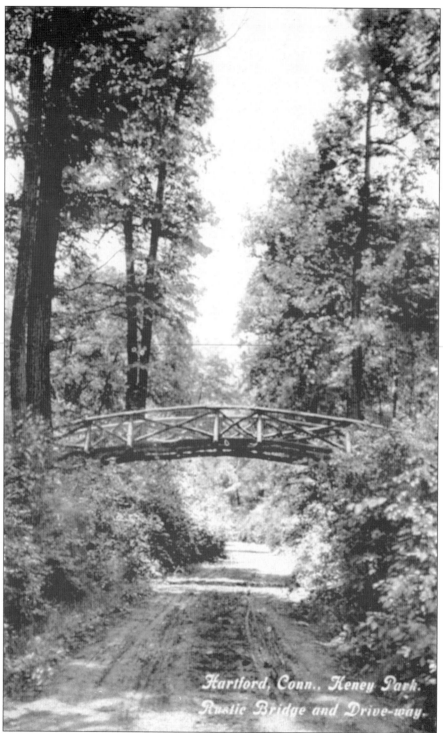

Hartford, Conn., Keney Park.
Rustic Bridge and Drive-way.

The various sections of the park, which crossed city streets, were connected by a series of carriage drives and walkways that were more than eight miles long. Over time, these original layouts have been compromised but there is strong local support to recreate the Olmsted Plan.

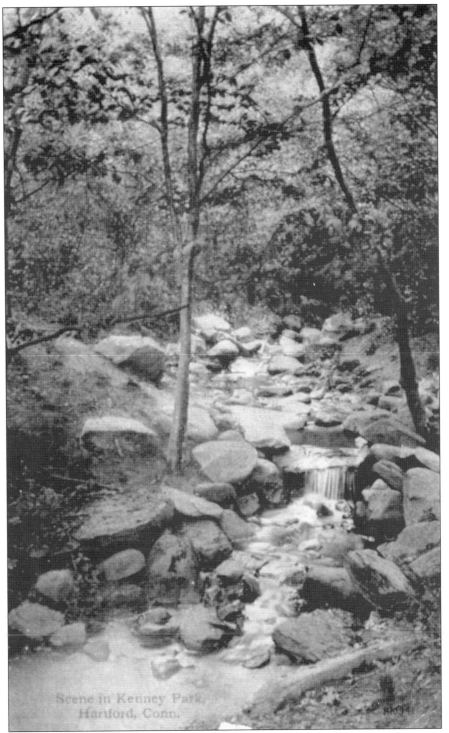

Scene in Kenney Park, Hartford, Conn.

Fortunately many of the features have survived including the trees and shrubs that were planted. The natural feel to the park, a deliberate design decision, was intended to give the visitor more of a pastoral experience. It was a great contrast to the other more formal parks in the city.

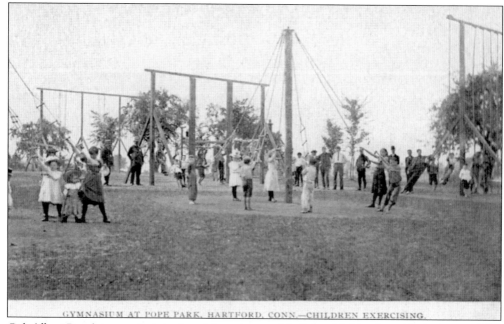

GYMNASIUM AT POPE PARK, HARTFORD, CONN.—CHILDREN EXERCISING.

Col. Albert Pope's ingenuity introduced Americans to his Columbia bicycle and Pope Automobile, both built in Hartford. He generously donated 90 acres to the city for use as a park. The result, completed in 1898 by the Olmsted Brothers, was Pope Park. It was greatly enjoyed by the families who worked in and lived near his Capitol Avenue and Parkville factories. The park today is being restored, embracing its former design.

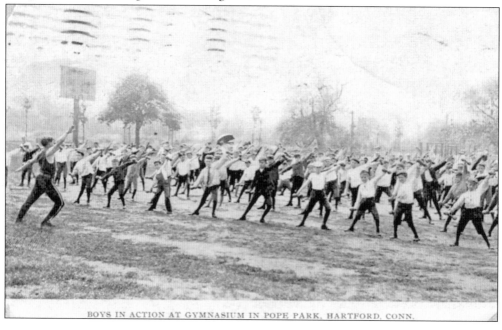

BOYS IN ACTION AT GYMNASIUM IN POPE PARK, HARTFORD, CONN.

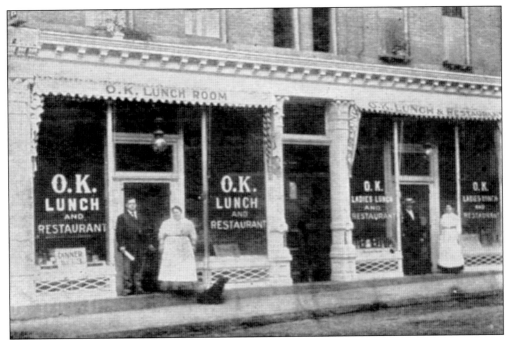

The O. K. Lunch and Restaurant at 10–12 Church Street provided the perfect place for refreshments after a day of activities. The establishment, with separate ladies' dining facilities, also advertised nicely furnished rooms to rent by proprietor Fred Schuman.

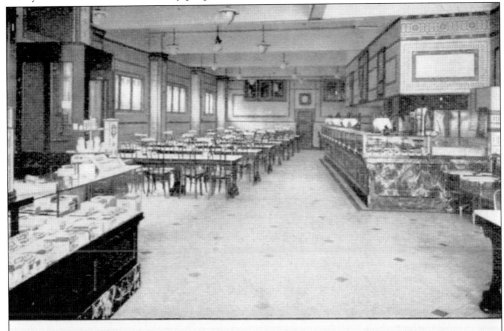

The New Baldwin's Eating Place, 631 Main Street, Hartford, Conn.

The New Baldwin's Eating Place was an alternate choice for a quick meal. Their motto was "there's quality and character behind every dish served here." The restaurant was across the street from the Wadsworth Atheneum in the commercial block between Mulberry and Gold Streets.

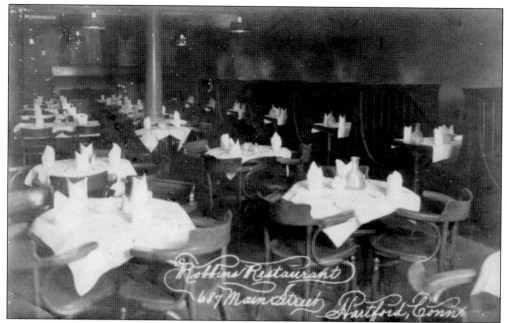

A block north was the location of Robbins Restaurant. It was in one the buildings that had encroached upon the Ancient Burying Ground, obstructing it from view. This was a sign of the strong economic growth and building boom that the city experienced in the decades after the Civil War.

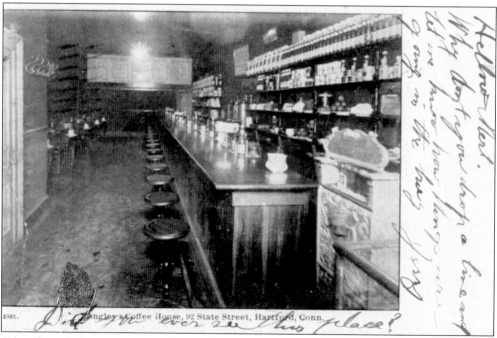

A less formal place to patronize, but no less inviting, was Longley's Coffee House at 92 State Street. It was located in a section of the Long Hotel complex across from the post office and Old State House. More of these places in Hartford would bring even more life back to downtown.

Ten

HARTFORD AS HOME

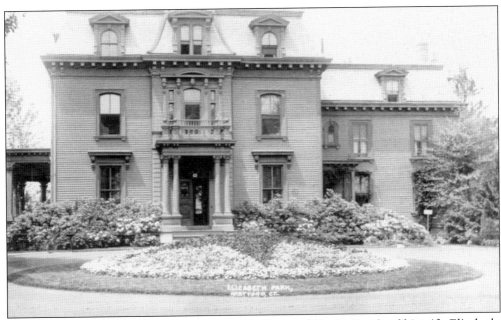

Before Elizabeth Park was created, it was once the home of Charles Pond and his wife, Elizabeth. When his wife predeceased him, he decided to bequeath his estate to the city in honor of his late wife. Upon his death in 1895, Elizabeth Park was established in the West End neighborhood. The Pond home however was demolished in 1956.

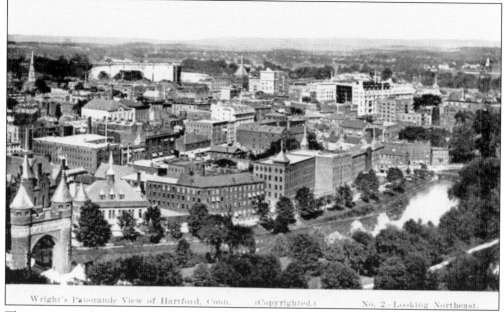

These eastern and northeastern views show the streets surrounding Bushnell Park. The Park River wrapped around the park, flowing under the Soldiers and Sailors Memorial Arch. Downtown had expanded along its banks with offices and factories to accommodate the growing economy.

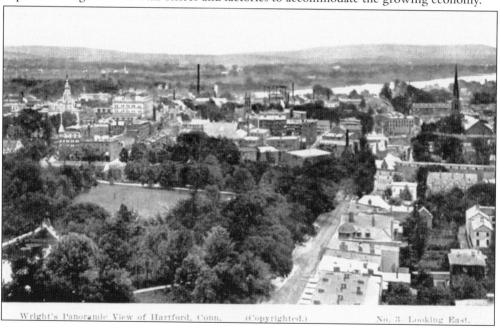

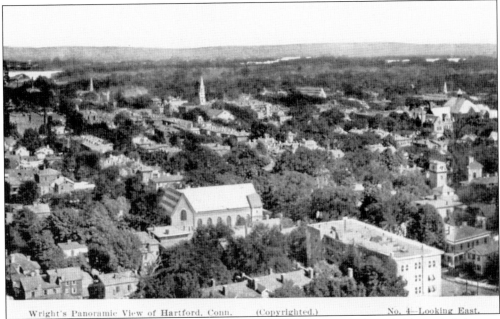

Turning to the east and southeast, one could see the residential flavor of the Capitol Avenue area east of Washington Street. Large homes were built here when it became fashionable to live south of the Park River. Most of this territory was torn down for state parking.

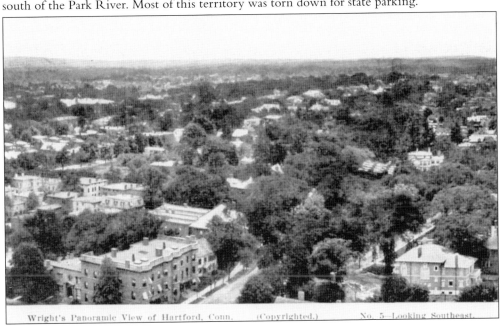

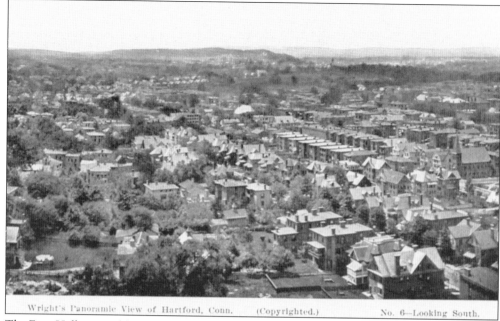

Wright's Panoramic View of Hartford, Conn. (Copyrighted.) No. 6—Looking South.

The Frog Hollow neighborhood absorbed many of the immigrant families who came to Hartford looking for a better way of life. They worked in the adjoining factories on Capitol Avenue and in Parkville. Much of the original worker housing stock has survived; this is evidence of just how robust the economy had been.

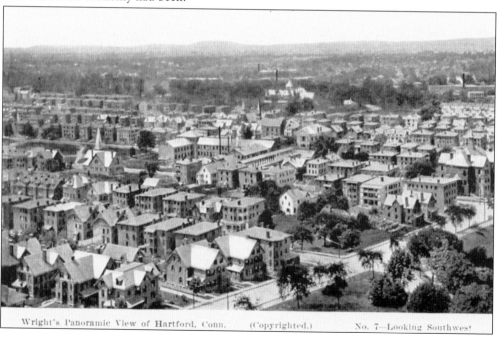

Wright's Panoramic View of Hartford, Conn. (Copyrighted.) No. 7—Looking Southwest

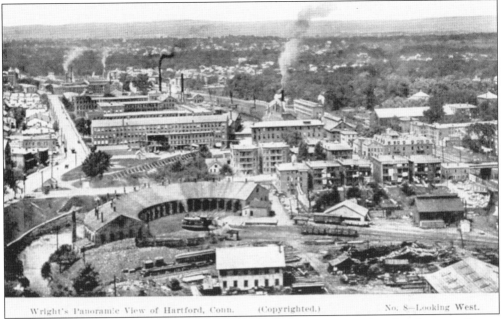

Western views showcase the West End and Asylum Hill neighborhoods. The roundhouse would become the site of the new state armory. The turreted Hartford Public High School was demolished to make way for the interstate highway that severed many historic neighborhoods from the rest of the city.

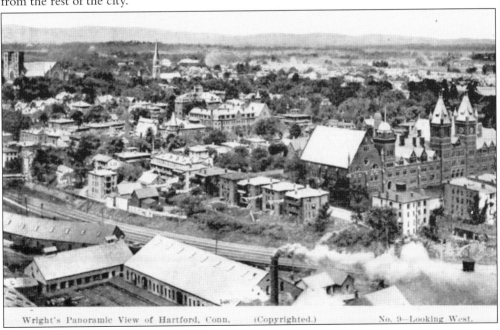

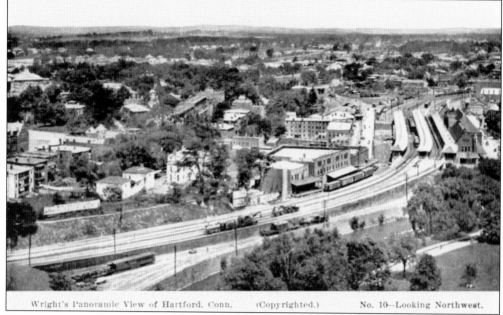

Wright's Panoramic View of Hartford, Conn. (Copyrighted.) No. 10—Looking Northwest.

The city has never healed from the decisions made 50 years ago. Hopefully plans for more mass-transit and engaging the principles of new urbanism and historic preservation will help reverse some of the effects that urban renewal wrought on Hartford.

The Hungerford (left) and Howe families lived on this section of Prospect Street between Atheneum and Grove Streets. The voracious expansion of the insurance industry consumed these properties along with one block of Grove Street.

Kimball and Wisedell created one of the most ornate facades in the city with the Goodwin Building of 1881. The structure survived intact until an extremely controversial project gutted the historic interior leaving only the exterior walls standing on Asylum and Haynes Streets.

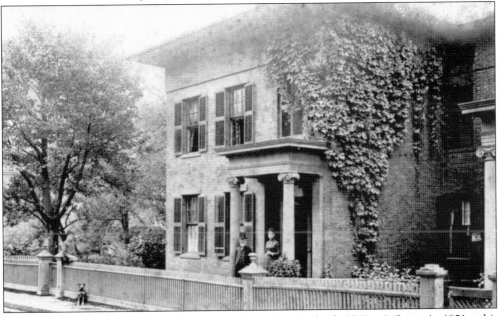

The name for Lewis Street came from Lewis Rowell, who built 25 Lewis Street in 1851 as his home. He duplicated his design when he added an adjoining structure to his property. The street has been altered over the decades but still lends a glimpse into residential downtown life of the 19th century.

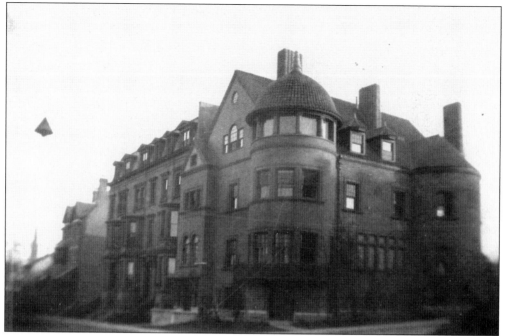

Elm Street must have been a most inviting place to live with views of Bushnell Park. The whimsical house at 91 Elm Street was home to the Olmstead and Hillyer families. By 1917, most of the block had been purchased by the Phoenix Mutual Life Insurance Company for the site of their new headquarters.

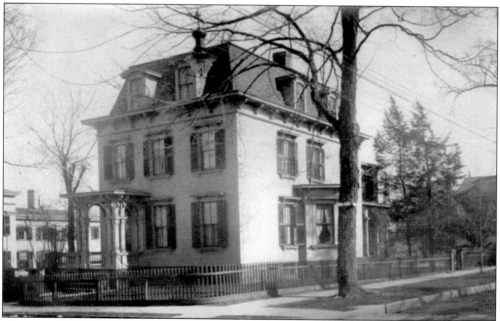

The address of this home was once 87–89 College Street (Capitol Avenue), as indicated by the sign on the corner tree. It was located on the southeast corner of College Street and West Street. The Packard home and the surrounding neighborhood were destined to become the sea of asphalt that now smothers the area.

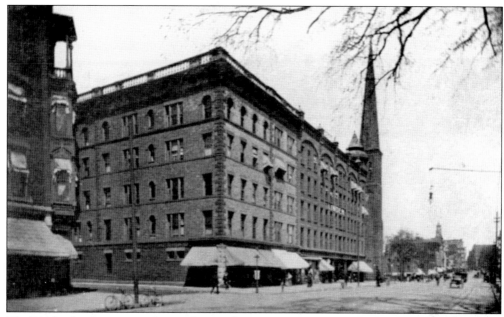

The Linden has been an anchor to the South Downtown neighborhood ever since Frederick S. Newman designed the 1891 apartment building on Main Street. It was commissioned by Frank Brown and James Thomson, owners of the famous downtown department store. John J. Dwyer drew the designs for the southern addition in 1895, which blends well with its older sibling.

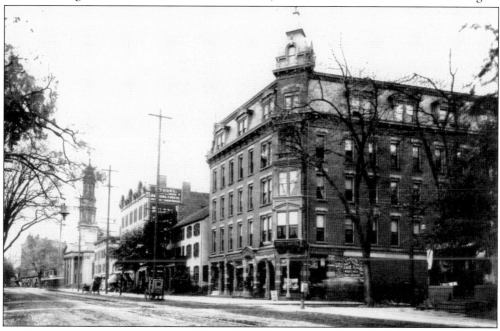

The Linden's earlier neighbor was the 1875 residential Hotel Capitol, built by John W. Gilbert. The Hammersley family lived next door until they moved to their 25 Capitol Avenue brownstone. Main Street was once lined with single family homes that gave way to larger structures. The Butler McCook House and Garden, across the street, is the only remaining 18th-century house left on Main Street.

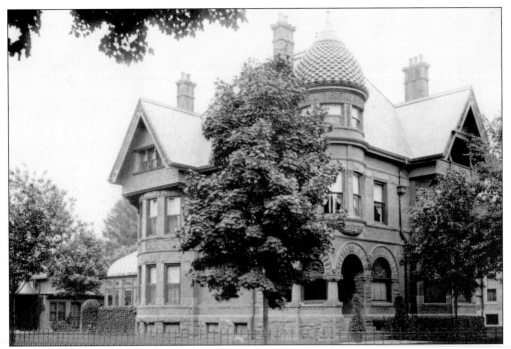

Evaporated milk brought riches to the Borden family. Gail Borden's daughter Mary Borden Munsill built her 2 Wethersfield Avenue Queen Anne mansion in 1893. The third floor still contains the ballroom and musicians' cupola. The interiors are in remarkable condition having been restored by previous owners.

Further down Wethersfield Avenue is the 1858 Day-Taylor Italianate house constructed by the building firm of H&S Bissell. Originally purchased by Albert Day, it was later sold to Munsill in 1879 before she built her own home. After that, it became the Edwin Taylor residence. One of the first historic preservation projects in the city was the 1979 restoration of this antebellum home.

The southern portion of Hartford has some of the youngest neighborhoods in the city. The house at 163 Adelaide Street was home to the Craemer family, who had arrived from Europe. The house still stands, although the porches have been enclosed. This section of the city continues to have some of the most diverse restaurants, bakeries, clubs, and residents, elements that make any city dynamic.

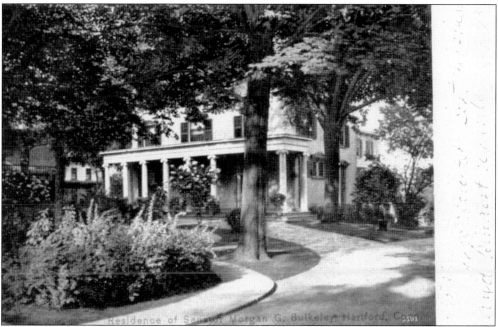

Mayor, senator, and governor, Morgan Gardner Bulkeley resided at 136 Washington Street. The tree-lined street was home to some of Hartford's most prominent families. Besides his political life, he was elected the first president of the National League of Professional Baseball Clubs in 1876. His home stood on the east side of Washington Street, and the grounds ran down to Cedar Street. The once picturesque street has been decimated by the intrusion of state and commercial buildings.

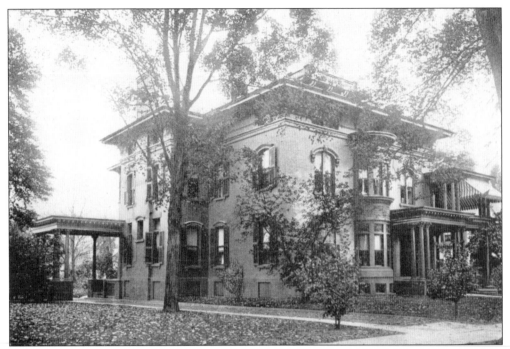

Three doors down, near the intersection with Park Street, is one of the last vestiges of the residential street. Lucius A. Barbour had some of the best sights of Hartford when he built his home in 1865. The third floor had a ballroom and a tower which provided 360 degree views of the city. The interiors today are in excellent condition while the exterior porches have been enclosed and the porte cochere removed. His Redfield, Hubburd, and Kennedy neighbors' homes have not survived.

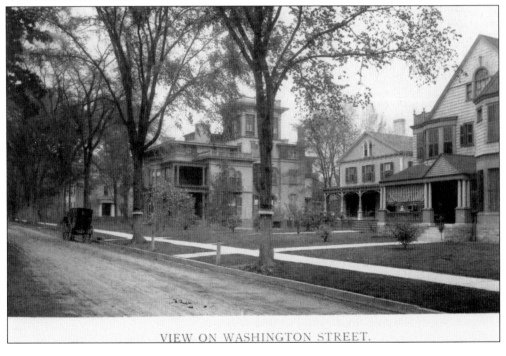

VIEW ON WASHINGTON STREET.

This area, so close to the new state capitol building, was called "Governors' Row" for the wealthy and politically influential families that produced senators and governors. Governor Henry Roberts lived on Lafayette Street. The lot is now a part of the state library and supreme court complex.

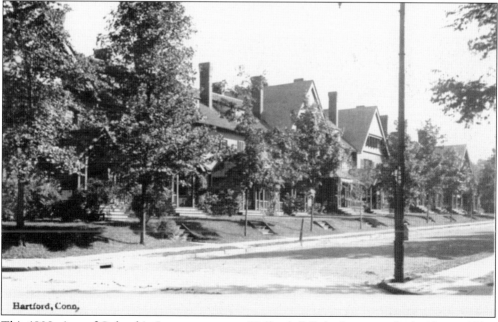

Hartford, Conn,

This 1908 view of Colombia Street was sent to Holland: "all the houses on both sides are alike, it is only one square long & is "no thoroughfare" as they say in London." The street was named for the Columbia bicycles that were manufactured across the street on Capitol Avenue. George Keller designed each 1888 row house to uniquely blend with each other.

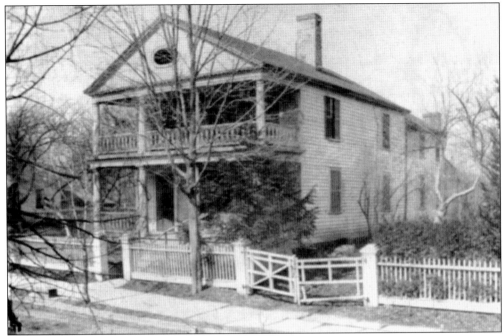

Lydia Sigourney was called the "sweet singer of Hartford," an internationally recognized poet. Time has forgotten the once well-known literary figure, as well as her last home on High Street near the corner of Walnut Street. After her death in 1865, Ebenezer Roberts purchased the site. He had built his own home on the opposite corner in 1854. It is now known as the Isham-Terry House, owned by Connecticut Landmarks. It survived the onslaught of the highway that tore through the neighborhood, claiming the Sigourney land. A visit there today is a trip back in time.

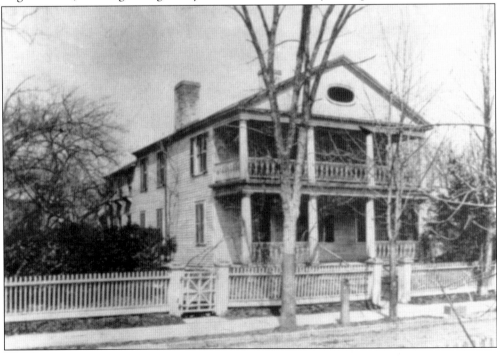

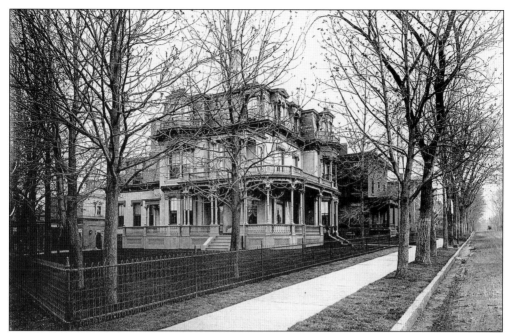

Francis Henry Richards became an inventor at the age of 15. He would eventually have 600 patents, become a patent attorney, and be affiliated with Pratt and Whitney, which started in Hartford. His stepdaughter Nellie F. Dole became the wife of Hartford mayor Miles B. Preston. The striking Second Empire home did not survive the changes that came to the Albany Avenue corridor.

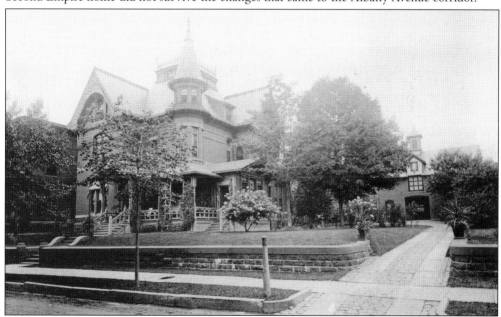

An expanding medical practice brought Charles Emerson Jones to 116 Ann Street. In the day, most doctors had home offices as did Dr. Oliver K. Isham, who had purchased the Roberts home in 1896 around the block from Ann Street. Jones remodeled the home to accommodate his patients and added a handsome stable. The grounds have been lost, but there is still a multitude of detail left on the house.

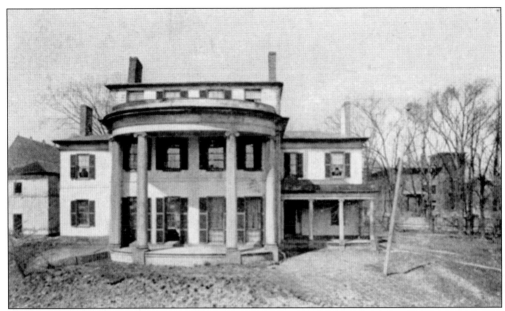

Lydia Sigourney's original homestead once crowned the entrance to Asylum Hill. She lamented the advent of the locomotive that spoiled her view and ruined the gardens and orchards that once were part of the property. The site, next to Bushnell Park would be changed by the insertion of the highway.

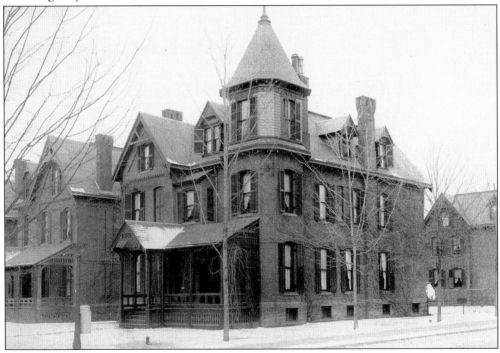

The home of William B. Clark once stood on the corner of Farmington Avenue and Laurel Street. An old Hartford native, he had gone to the old North School on High Street and eventually became the president of the Aetna Insurance Company. His unassuming home was demolished for an apartment building, while the home next door has survived.

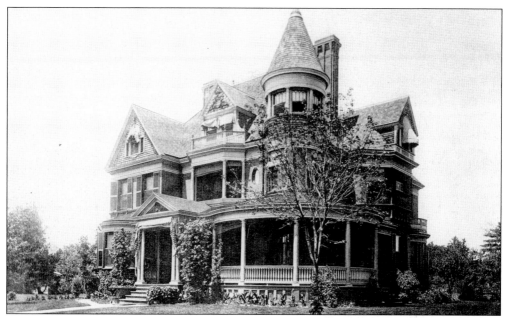

Ireland was the birthplace of the man who built his home at 236 Farmington Avenue. Patrick Garvan, a successful paper merchant, purchased an acre of land from the Niles estate in 1892. A year later, he built his impressive abode. Through his efforts as president of the board of park commissioners, he established Riverside Park. The graceful home that stood between Laurel and Sigourney Streets has been replaced by a commercial block.

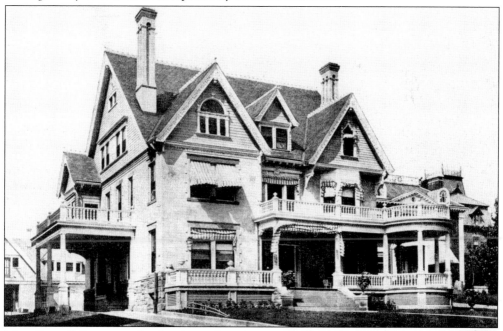

Mary Rowell Storrs was the daughter of Lewis Rowell, who had established himself on Lewis Street. Fashionable Farmington Avenue was the place to build her home across from the Nook Farm enclave. She chose Isaac A. Allen Jr. as the architect. The former carriage house has been transformed into the Hartford Children's Theatre.

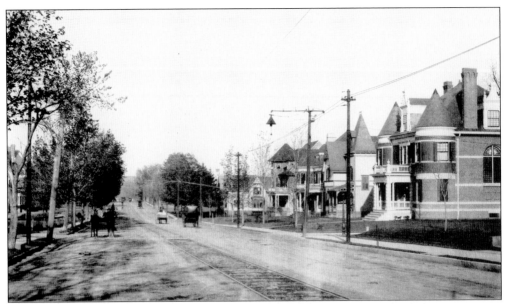

It is hard to imagine Farmington Avenue was once a wide avenue of single family homes. The encroachment of insurance companies and commercialization of the street have greatly altered its appearance. Committed efforts are being made to turn the avenue into more of an inviting, pedestrian friendly environment.

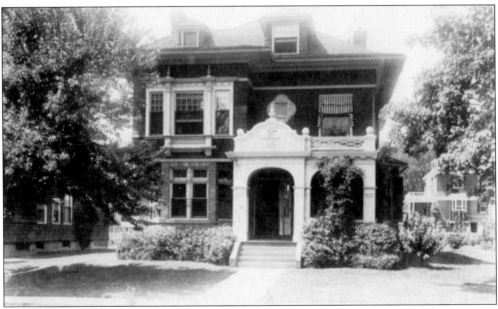

The West End side streets of Farmington Avenue have retained most of the residential homes constructed during the westward expansion of the city. The residence of Henry H. Hills is one such home that has changed little since it was first photographed, with the exception of an altered front porch. John and Dana Palmieri, the current owners who take meticulous care of the historic home, have had thoughts about restoring the entrance to its original appearance.

The West Boulevard development connected the older neighborhoods in the West End neighborhood. Construction of homes in the early 1900s was evidence of the upward mobility of the skilled workers who had moved into the area. This scenic boulevard is the latest to become a National Register of Historic Places historic district.

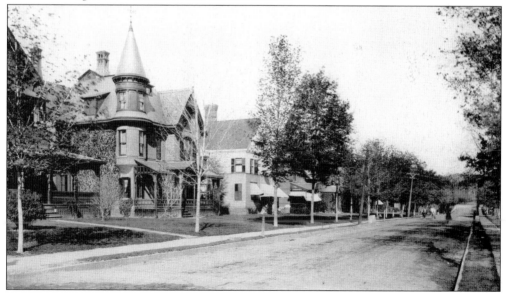

Asylum Hill has suffered through the years with destruction of some of its historic housing fabric that made the neighborhood such a desirable location. However, strong community activism and investment have continued to preserve and revitalize the area. Apartments had replaced some of the homes on Collins Street except for the Joseph W. Cone house. The turreted house stills stands, although it has lost its original front porch.

The Collins family was a prosperous merchant and politically connected family. Their estates formed a compound surrounded by Woodland, Asylum, Atwood, and Collins Streets. This large tract would give way to the insurance industry and is now a portion of the St. Francis Hospital campus.

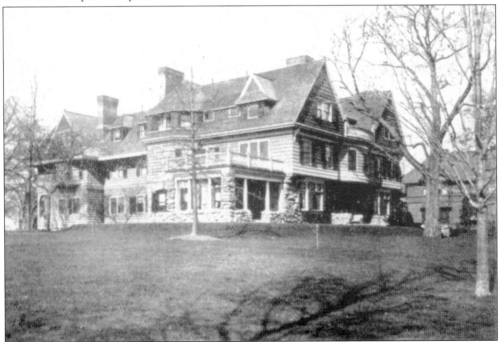

The corner of Asylum Avenue and Gillett Street was the location of the Charles R. Forrest dwelling. An incredible stone porch accessorized the large home at 1045 Asylum Avenue. The gradual evolution of the street did not spare this unique home.

George J. Capewell amassed a fortune with his horse nail factory. His home still presides at 903 Asylum Avenue, although his factory is in a perilous state on Charter Oak Avenue. A new commercial historic tax credit program will hopefully aid in its restoration. His children eerily mirrored the life of the Isham children on High Street. The family moved to larger quarters at 969 Asylum Avenue, and the son and two daughters never married or lived away from the home. They would all live there until their deaths.

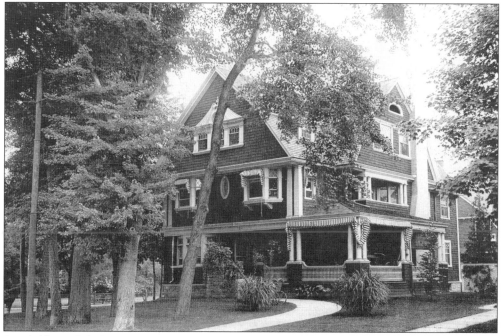

A neighbor of theirs was George Lewis Chase. His inviting home was down the road on the corner with Willard Street. He was associated with the Hartford Fire Insurance Company. The large homes that once graced this section of Asylum Avenue have all but disappeared.

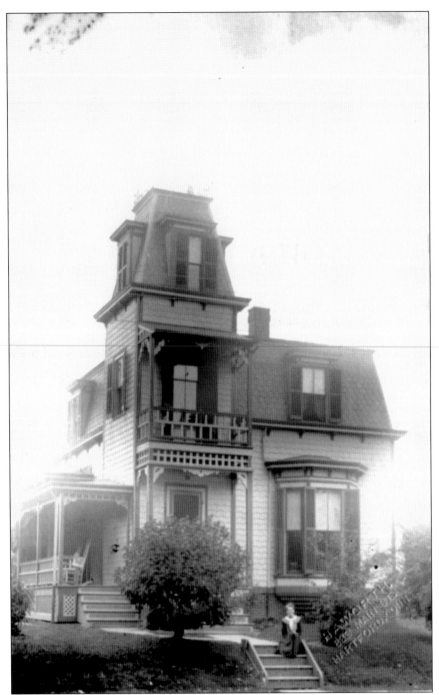

This charming Second Empire house at 21 Sherman Street was built in 1877. It has gone through numerous changes but is now being lovingly restored by its owners, Mark Fisher and Luciano Valles. Such residents are critical to the revitalization of the city. They care for their home, appreciate its history, and work towards preserving the story it will tell for generations to come. Pride of place, instilled in the hearts of Hartford's residents, will continue to polish the architectural gems that embellish the capital city of Connecticut.

BIBLIOGRAPHY

Andrews, Gregory E., and David F. Ransom. *Structures and Styles: Guided Tours of Hartford Architecture.* Hartford, CT: Connecticut Historical Society and Connecticut Architecture Foundation, 1988.

Baker and Tilden. *Atlas of Hartford City and County.* Hartford, CT: Baker and Tilden, 1869.

Dedication of St. Michael's Church, June 24, 1906.

Elihu Geer's Sons, Canvassers and Compilers. *Geer's City Directory.* Hartford, CT: Hartford Printing Company, 1899 and 1907.

Geer's Hartford and East Hartford Directory. Hartford, CT: 1899 and 1907.

L. J. Richards and Company. *Atlas of the City of Hartford.* Springfield, MA: L. J. Richards and Company, 1896.

Richards Map Company. *Atlas of the City of Hartford and the Town of West Hartford.* Springfield, MA: Richards Map Company, 1909.

Sanborn Map Company. *Atlas of the City of Hartford and the Town of West Hartford.* New York: Sanborn Map Company, 1917.

Across America, People are Discovering Something Wonderful. *Their Heritage.*

Arcadia Publishing is the leading local history publisher in the United States. With more than 3,000 titles in print and hundreds of new titles released every year, Arcadia has extensive specialized experience chronicling the history of communities and celebrating America's hidden stories, bringing to life the people, places, and events from the past. To discover the history of other communities across the nation, please visit:

www.arcadiapublishing.com

Customized search tools allow you to find regional history books about the town where you grew up, the cities where your friends and family live, the town where your parents met, or even that retirement spot you've been dreaming about.